Advance Praise for

If Venice D

"An impassioned plea that every lover of Venice, urban plan-
ner, architect, and cultural historian should read."
—*Kirkus Reviews* (Starred review)

"A chilling account of the slow agony of Venice as illustrative
of a global consumerist epidemic. Richly documented and
imbued with deep angst about this supreme urban creation."
—Philippe de Montebello, former director of
the Metropolitan Museum of Art

"Anyone interested in learning what is really going on in
Venice should read this book." —Donna Leon, author of
My Venice and Other Essays and *Death at La Fenice*

"This book valiantly shows why Venice—crossroads of civ-
ilization, art and commerce, eternal place of love—cannot
be allowed to perish."
—Diane von Furstenberg, Vice Chairman,
Venetian Heritage Council

"Settis shows how the tragedy of Venice could happen to any
city which has a past. It's a powerful polemic."
—Richard Sennett, author of
The Fall of Public Man and Professor of Sociology,
New York University and the London School of Economics

"Venice is indeed unique but it stands for all cities in this
eloquent, furious blast against the commodification of our

planet and the relentless destruction of human communities by the mentality of markets."

—ROGER CROWLEY, author of
City of Fortune: How Venice Ruled the Seas

"An elegant indictment of the challenges Venice faces from today's rapacious economic environment. Settis offers an ethical prescription for re-imagining and resuscitating the historical uniqueness of Venice and Venetian life."

—ERIC DENKER, coauthor of
No Vulgar Hotel: The Desire and Pursuit of Venice and
Senior Lecturer, National Gallery of Art

"A lament for the day-by-day destruction of great beauty ... full of anger and disappointment at what the author sees as the moral bankruptcy of Italy today." —*THE ART NEWSPAPER*

"The vision of Settis is particularly gloomy and pessimistic, but there is still hope." —*CORRIERE DELLA SERA*

"Salvatore Settis wants to curb the sellout of cities ... Balancing sharp intellect and moral indignation, lucid writing and impassioned argument, his polemic makes for captivating reading."

—*FRANKFURTER ALLGEMEINE ZEITUNG*

"Settis's analysis extends to all cities. Only active citizenship can save them from the greed of real estate speculators."

—DESMOND O'GRADY, former European editor of
The Transatlantic Review and author of *The Road Taken*

"With his book, Settis has clarified what conservationism and the protection of our cultural heritage should mean."

—*IL MANIFESTO*

If Venice Dies

Salvatore Settis

Translated by André Naffis-Sahely

NEW VESSEL PRESS
NEW YORK

IF VENICE DIES

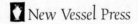 New Vessel Press

www.newvesselpress.com

First published in Italian in 2014 as *Se Venezia muore*.
Copyright © 2015 Salvatore Settis. Published by arrangement with
Marco Vigevani & Associati Agenzia Letteraria.
Translation Copyright © 2016 André Naffis-Sahely

The translation of this work has been funded by SEPS
SEGRETARIATO EUROPEO PER LE PUBBLICAZIONI SCIENTIFICHE

SEPS
SEGRETARIATO EUROPEO PER LE PUBBLICAZIONI SCIENTIFICHE

Via Val d'Aposa 7 - 40123 Bologna - Italy
seps@seps.it - www.seps.it

Cover design: Liana Finck
Book design: Beth Steidle

Library of Congress Cataloging-in-Publication Data
Settis, Salvatore
[Se Venezia muore. English]
If Venice Dies/ Salvatore Settis; translation by André Naffis-Sa-
hely
p. cm.
ISBN 978-1-939931-37-5
Library of Congress Control Number 2016902102
 I. Italy — Nonfiction

Acknowledgments

I would like to thank the following people for their suggestions, help, and criticism during the writing of this book: Andrea Bosco, Donatella Calabi, Maria Luisa Catoni, Anna Fava, Lucia Franchi, Claudia Ferrazzi, Denise La Monica, Enrica Zaira Merlo, Tomaso Montanari, Myriam Pilutti Namer, Alessandro Poggio, Filippomaria Pontani, Federica Rossi, Antonella Tarpino, Marco Vigevani, Marina Zanazzo and my sons, Andrea and Bruno.

As ever, my wife, Michela, a native of the Veneto, as well as my life partner, was my most trusted, patient, and perceptive reader, and thus this book is dedicated to her.

Table of Contents

If Venice Dies

CHAPTER I

Forgetful Athens

Cities tend to die in three ways: when a ruthless enemy destroys them (like Carthage, which Rome razed in 146 BCE); when foreign invaders violently colonize them, driving out the indigenous inhabitants and their gods (in the case of Tenochtitlan, the capital of the Aztecs, when the Spanish conquistadores destroyed it in 1521 to build Mexico City atop its ruins); or, finally, when their citizens forget who they are and become strangers to themselves and thereby their own worst enemies without even realizing it. This happened to the city of Athens, which after experiencing the glory of its classical period—the Parthenon marbles, Phidias's sculptures, and the cultural and historical events shaped by Aeschylus, Sophocles, Euripides, Pericles, Demosthenes, and Praxiteles—lost its political independence (first falling under Macedonia's sway, then Rome's) and later its cultural initiative but also became oblivious to its own identity.

Overwhelmed by a staid, facile classicism imparted to us early on at school, we all too often think of Athens as having remained frozen in the whiteness of its marbles for centuries until it finally blossomed anew, almost as though it had stirred from a deep slumber, following the Greek War of Independence in 1827. Yet nothing could be further from the truth: when Michael Choniates, who hailed from Constantinople,

was appointed archbishop of Athens in the late twelfth century, he was astonished by the ignorance of the Athenians, who were unaware of their city's former glories, and weren't able to tell foreign visitors about their still intact temples, nor could they point out the places where Socrates, Plato, and Aristotle had preached their doctrines.

Throughout its incredibly long Middle Ages, the Parthenon in that forgetful Athens had been converted into a church, its walls festooned with icons and other religious paintings, while its interiors reverberated with liturgical chants and the scent of incense hovered in the air. Following the Fourth Crusade in 1204, it became a Latin cathedral, and was repeatedly looted by the Venetians and Florentines, while the Athenians themselves didn't lift a finger to defend it or bother to raise a voice in protest and remember its history and glory. When Athens was conquered by the Ottoman Turks in 1456—and the Parthenon-Church was turned into a mosque—the city even lost its name. What remained was a wretched village with a few huts scattered among the ruins, while the local population, which had been reduced to a few thousand, had started to call the city Satines—or Sethines—a bastardization that Rome was never subjected to. Nevertheless, the Athenians' oblivion had its roots in much earlier times. Around the year 430 CE, the Neoplatonic philosopher Proclus Lycaeus, who lived close to the Acropolis, tells us that he was visited in a dream by Athena—the goddess of the Parthenon—who, having been driven from her temple, had come to seek his hospitality. This nostalgic dream not only perfectly encapsulates the end of a religion and the destruction of its monuments, but ultimately the eclipse of a culture and its inhabitants' loss of self-awareness.

As often happens to those—even cities—who are seized by a collective amnesia, they also end up losing their dignity. If

something remains of their ancient spirit, it must seek refuge elsewhere; in the case of Athens, for instance, in Constantinople, and from there, Moscow, or the leading centers of Italian humanism. As for us in the present day, we've even forgotten that Athens forgot its own identity. But it would be good to keep the darkness of that oblivion in mind lest we be felled by the same disease. After all, the darkness of oblivion doesn't suddenly swoop down on a community, but rather descends slowly and unsteadily upon it, like a hesitant, final curtain. One need not be complicit in this act for that curtain to fall all the way to the floor, for everything to be enveloped by the blurriness of that night; one need simply be indifferent. Thus, it is supremely important to catch any and all symptoms of forgetfulness as quickly as possible and immediately address the problem, just as we do when it comes to our mental and physical well-being.

It has become fashionable, in these violent, corrupt times of ours, to repeat the mantra that "beauty will save the world." Dostoevsky has Prince Myshkin, the hero of *The Idiot*, voice these very words, which are nowadays cited far too often in Italy, like a soothing, self-absolving litany that's always quoted out of context. "What sort of beauty will save the world?" the young Ippolit asks the prince, adding that "the reason he has such playful ideas is that he is in love." Because "beauty is an enigma," even though Aglaya Ivanovna's beauty "could turn the world upside down." For Prince Myshkin, beauty is a state of grace, an "extraordinary quickening of self-consciousness" triggered by "worship," an altered state he experiences prior to each epileptic seizure. ("Yes, for this moment, one might give one's whole life!") The beauty of which he speaks is thus beyond us, something we can abandon ourselves to, or fall in love with, or pray to, and is the "reconciliation and ecstatic devotional merging in the highest synthesis of life."

The beauty of cities and landscapes is something else entirely: it's a tangible horizon, and not some lofty ideal; a heritage that doesn't belong to the individual, but rather to his or her community; it doesn't entail sudden revelations, but instead a continuously evolving narrative composed of plans, glances, gestures, skills, and memories. It isn't actually beyond us because we are in fact an essential part of it, because the same air and blood binds the great monuments of art, nature, and history to those who created them, or look after them, or dwell in them. It is made up of the real experiences of the men and women of our time and they—or rather we—are the link that connects past generations to those yet to come. The supreme beauty of Athens didn't prevent that city from falling into self-oblivion, nor did it shield it from the pillaging and devastation that followed in its wake. Nor did it prevent the Florentine Acciaioli family—who ruled the Duchy of Athens—from turning the Propylaea of the Acropolis into a fortified palace, roughly around the year 1403, or the Ottoman Turks from using the Parthenon as a gunpowder warehouse. Nor did it hinder the Venetian General Francesco Morosini from firing his cannons at it on September 26, 1687, blowing large parts to smithereens. More than seven hundred traces of cannonball shrapnel can still be seen on the marbles of Pericles and Phidias. Looking around and surrendering ourselves to the beauty of our cities and our landscapes cannot suffice—it has never sufficed for us to expect a miraculous salvation from beauty that will absolve us of all responsibility. No: on the contrary, we the living should nurture beauty on a daily basis if we want some of it to survive, so that we may enjoy it and ensure its survival after our death. Beauty can't save anyone or anything if we don't first know how to save beauty, and with that—our culture, our history, our memory, and our economy, in other words, life itself.

CHAPTER II

A Venice without Venetians

The eclipse of memory hangs over us all, posing a threat to our civil society, undermining our future, and suffocating the present. If the city is the ideal and quintessential form of human community, Venice isn't just the supreme symbol of this cluster of meanings, but also of its decline, not just in Italy, but in the rest of the world. If Venice dies, it won't be at the hands of a cruel enemy, or a conqueror's intrusion. It will be because it has forgotten its own identity. For our modern communities, oblivion doesn't simply mean forgetting one's own history, or developing a morbid addiction to beauty, which is experienced as though it were a lifeless ornament that should console us. It primarily means forgetting something essential: the specific role that a city plays in comparison to others, its uniqueness, and its diversity, virtues that Venice possesses more than any other city in the world. Just as all individuals pride themselves on their own special qualities, and yet can exhibit these talents or put them to fruitful use only when seen in perspective against the talents and experiences of others, the same applies to our cities. Every city is unique by dint of its own historical events, its urban form, its architectural styles, the materials with which it was built, the landscapes in which it was implanted. As such, the way its inhabitants live and love their native city is also unique. Every city should therefore build its future on the

foundations of this heritage. Nevertheless, every city is also emblematic of a particular kind of development, and as such draws meaning, strength, and a sense of destiny through its interplay of similarities and differences with other cities. Every city is the result of an enormous number of choices made over a great span of time, choices that could have been made differently at every fork in the road. Thus, each city contains a number of other cities within it: the city it once was, as well as all the other cities it could have been, and yet never became—potentialities that one can sometimes see embodied in other cities, either through resemblances or affinities. The physical weft of the city and the morphology of its location intersect with the warp of its institutions and the events that played out on its stage, the plans and hopes of the people who once dwelled in it, as well as residents of the future. The successive generations that have woven this tapestry are essential parts of one another, and are both its begetters and its begotten.

In Italy, which has been called the nation of the hundred cities since it was formed of a large ensemble of ancient municipalities, town planning was born and reborn many times over: from Greek and Etruscan cities, to Rome and its dominions, through the long, fertile Middle Ages and finally through the spectacular sequence seen from the Renaissance to the present day. It thereby underwent profound renewals each time, while retaining and reusing walls, roads, temples, centuries-old bridges, all of which bore strong traces of a past too rich to be overlooked. This is why we can still see enough of those old Italian cities to recognize—or imagine—the same roads where Virgil, Dante, or Ariosto walked. The mental journey that takes us from Sicily all the way to the Alps allows us to witness an incomparable variety of urban dwellings, whose spirits were embodied not only in churches, public

squares, and palaces, but also in institutions and governance practices, from those of the Kings of Naples to the maritime republics of Venice and Genoa. Against those varied backdrops, there was a constant process of thinking and rethinking the nature of citizenship, with the present being examined in light of the past. We can instantly differentiate a photo of Palermo or Naples from one of Genoa or Venice, even though, in the midst of that spectacular diversity, one can still perceive a common (Italian) thread, in the same manner that one can see references and connections to Sicilian poets in Dante's Tuscan verses, or the way Alessandro Manzoni's novel *The Betrothed* exemplifies how Italy's 19th century political unification was accompanied by the development of a unified Italian literary language constructed from regional tongues. Temporal continuity and physical space are the two poles between which the story of Italian cities (and thus civilization) has oscillated: a history which includes both industry and the arts, music and poetry, farming and illuminated manuscripts, architects and physicians. In this interplay of fixed and variable points, what emerges as a uniquely recognizable feature of Italian urbanism—which became one of the most important models for the rest of the world—was the polarity between the city and the countryside, which constantly reproposes the contrast between *natural* space and urban space, or the natural order of things and the *cultural* order of things. Thus, each city is living testament to its own history, but is also the stony incarnation of the people who live in it, preserve it, and transform it. A city and its people are a single unity, a hub that links the experience of the living with the memory of material objects. Yet who are Venice's inhabitants? Sheltered by the glories of that Most Noble and Singular City, the title that the scholar Francesco Sansovino gave to his 1581 book about Venice, do

its people truly know how to retain their city's essence and preserve its identity?

According to the current administrative arrangement, the area governed by the municipality of Venice also includes a vast tract of the mainland that comprises the cities of Mestre and Marghera as well as the Marco Polo Airport in Tessera. This is where the majority of Venice's population migrated in the past decades, particularly the younger generations. Concurrent with this internal relocation, the overall population of the entire area fell by over one hundred thousand inhabitants from 1971 to 2011, dropping from 363,062 to 263,996. Yet if one looks at the demographic data from Venice's historical center, as one should, this drop is even more dramatic:

1540	129,971
1624	141,625
1631	98,000 (approx.) (following the plague of 1630)
1760	149,476
1797	137,240 (year the Republic was abolished)
1871	128,787
1951	174,808
1961	137,150
1971	108,426
1981	93,598
1991	76,644
2001	65,695
2012	58,606 (June 30)
2013	57,539 (October 21)
2014	56,684 (June 30)
2015	56,072 (June 30)

As we can see, the only other time Venice experienced a population drop comparable to the present one over the past six centuries was in the aftermath of the plague of 1630, when it took the city's population over a century to return to its previous levels. Although the extant demographic data is less reliable, the plague of 1348 proved to be equally devastating, after which it's estimated that the population dropped from about 120,000 to 58,000: just a little over today's figures. Yet starting in the 1970s, a new kind of plague broke out in Venice. In 1950, the city registered 1,924 births versus 1,932 deaths (more or less the same). In 2000, on the other hand, there were 404 births versus 1,058 deaths. The combined results of an aging population, an exodus to the mainland, the breakup of families, a low birthrate, and other factors paint a portrait of a city on the run from itself. This allows us to understand why the Morelli Pharmacy in Campo San Bartolomeo put up a meter that displays the daily drop in Venice's inhabitants. This dramatic countdown wasn't organized by a public body, but rather by a group of local citizens. One of them, Matteo Secchi, even went so far as to say: "We'll soon celebrate Venice's funeral and carry the coffin in a procession all the way to city hall." Moreover, the Venetians who live in the historic center "don't actually get to elect their own mayor since they are outnumbered three times over by Mestre's inhabitants (who live on the mainland)," according to economist Francesco Giavazzi.

Thus, who are Venice's real inhabitants? What kind of plague is responsible for their annihilation? While the city steadily empties out, the rich and famous continue to flock to it, ready to pay any price to purchase a house—which becomes a status symbol they tend to use for only five days a year. This influx has dramatically distorted the market, raising prices in a

manner that drives Venetians out of their own city, making it a capital of second-home owners, who briefly appear with great pomp and flash before vanishing into the ether for months at a time. In the meantime, 8 million tourists pour into Venice's streets and canals each year, for a total of 34 million nights, compared to the city's maximum carrying capacity of 12 million (Giuseppe Tattara, *Contare il crocerismo* / Quantifying Cruising, 2014), meaning that tourists outnumber Venetians 140 to 1. This devastating disproportion has had the impact of a bomb, profoundly altering the population and the economy. A tourist monoculture now dominates a city which banishes its native citizens and shackles the survival of those who remain to their willingness to serve. Venice no longer seems capable of creating anything other than bed-and-breakfasts, hotels and restaurants, real estate agencies, souvenir shops devoted to traditional products (from glass to masks), and staging phony carnivals, thereby applying some melancholy makeup to its features in order to give the city an atmosphere of a perpetual county fair; this briefly allows it to forget the plague which afflicts it and is wiping out its inhabitants while tearing apart its social fabric, cohesion, and civic culture.

However, the tourist monoculture that has driven Venetians from Venice continues to hold sway, so much so that the 2,400 hotels and other overnight accommodations the city currently has no longer satisfy its appetites. If an initiative launched by the Veneto Region isn't stopped in its tracks, the newspaper *Corriere della Sera* has reported, the total number of guest quarters may soon reach fifty thousand in the city's historic center and thereby take it over in entirety. Just along the Grand Canal, the unique "highway" of a unique city, the years since 2000 have seen the closure of the National Research Council, the local education agency, judicial offices,

the transport authority, the Mediocredito Bank, the German Consulate, in addition to twenty property units, medical practices, and stores, in order to make way for sixteen new hotels (meaning an average of two to three each year), for a total of 797 rooms; several of them are luxury properties. The plurality of functions once performed by Venice's historic city center has now died and been supplanted by a tourist monoculture.

Yet Venice's real people aren't tourists, even those devoted visitors among them who spend a focused amount of time there, say a few days or a few weeks. Nor are they those who own second, or third, or even fourth homes there. None of those who belong to these categories could ever be the kind of men and women that a real city needs: the lifeblood that flows through the veins of its streets and squares; the makers and guardians of its memories; a community that identifies with the physical shape of the city and its ethical reasoning, *Le pietre e il popolo* or *The People and the Stones* (like the title of a book by Tomaso Montanari).

Can Venetians today ever amount to more than an increasingly dwindling cluster lost amid an ocean of second-home owners or visitors, like the survivors of some kind of deforestation? They might, but not if we abandon the ones who are waging a "proud, desperate struggle to survive, while their city is being constantly invaded by millions of foreigners on a daily basis who will never truly invest in that city" (Polly Coles, *The Politics of Washing: Real Life in Venice*, 2014). Venice runs the risk of soon becoming devoid of Venetians. Should we not want this to happen, even non-Venetians such as us must become part of that city's people, become the custodians of its beauty and memory and devote ourselves to nurturing its future. We must do so even during our infrequent visits, and above all seek to pay it the kind of homage it seeks from us. We

should strongly ponder the highest level of urban form which Venice represents, the lifestyle (and notion of citizenship) that it embodies, and the need to come up with a plan to reanimate it so that its blood (i.e., its people) flows through its veins once again. We must do so because thinking about Venice will allow us to better understand other cities, including the ones we live in, and better grasp their meaning and their destiny (including our own).

CHAPTER III

―――――

The Invisible City

Do cities have souls? The distinction and opposition between "body" and "soul" has been expressed in myriad ways across all human cultures. Let us consider Socrates: he believed that the soul (or psyche) was the true self; comprising self-consciousness and consciousness of the world, this soul constituted the principle of knowledge, an inner tribunal, a moral, rational agent, a modus operandi that is governed by a code of ethics. Thus, the aim of an individual's conduct must be to "care for the soul," or, in other words, to master the ability to know which path to pursue and to adhere to it in the *polis* (the city, or body of citizens). Thus, body and soul do not contradict themselves; instead they complement each other, being two different aspects of the same individuality. The body is the instrument of the soul: the latter guides the former and controls its impulses in order to achieve high ethical aims.

Without resorting to further formulations, or translating the relationship between the "body" and the "soul" into terms more suitable to our times, let's try to use this ancient doctrine as a powerful metaphorical device to scrutinize not only the individual, but human communities as a whole; a process which would examine the polis not only as an institutional structure and the theater of democracy, but also the city's actual physical shape. Let's try to think of the city as having a

body (made of walls, buildings, squares, and streets, etc.), but also a soul; and its soul doesn't merely include its inhabitants, its men and women, but also a living tapestry of stories, memories, principles, languages, desires, institutions, and plans that led to its present shape and which will guide its future development. A city without a soul, made up of just walls, would be nothing but a carcass, a funereal scene, just like what one might see in the aftermath of a neutron bomb that has wiped out all trace of life, leaving the city's buildings intact and ready to be used by the approaching invader. Instead, as far as our experience shows, the cities of walls and the cities of men coexist side by side. There is a soul inside that city of men: its community. And this community is an invisible city.

This invisible city is governed by unwritten laws, which by virtue of being uncodified are all the more binding: for instance, a sharp distinction (marked by both conventional and unequivocal signs) between the city and countryside, between urbanized space and the natural space around it. This was the role that walls played during medieval times, which can still be seen in places like Lucca. Unique even in this respect, Venice instead is the supreme example of how water led to the transition from a natural order to a cultural one. The Lagoon, the ecosystem that encompasses the city, is to Venice what the countryside was to other cities (and still is in some cases). The Lagoon's landscape was Venice's countryside, since it was a place where crops were grown (fruit, vegetables, vines), and which provided the city with other kinds of victuals (fish, salt), but it was a countryside that was closely linked to the city because its islands hosted facilities that were crucial to everyday life (monasteries, hospices, leper colonies, boathouses), as well as various settlements that were used on a daily basis.

Another rule of the game, which is inextricably linked to the "invisible city" and thus also with its physical shape, is the tension between the act of founding, which is precise and ritualistic, and the slow unfolding of the social fabric. The act of founding a city, often rendered into stories or myths, like Romulus plowing his furrow around Rome's proposed site before a single house had been built, implies that the invisible city already exists in the mind before the visible city is actually built. This soul, which preexists the physical city, inspires a set of rules linked to specific functions: architectural styles, for instance, as well as hierarchies, neighborhoods and streets, languages and building techniques. Over the course of time, the invisible city molds and models the visible city, shaping it in its own likeness, transforming the temples of pagan gods into churches or mosques, and the former palaces of kings into museums. It also constantly changes the relationship between private and public places, the latter being devoted to religious, political, civic, and commercial life. Thus, the visible city tells the story of the invisible city, albeit sometimes only through scattered remnants. Like a palimpsest, the streets and houses we see today inform us about the social orders, tensions, and conflicts of our past.

The invisible city walks alongside us, and we also carry it within us: because *we* are the invisible city. "This city which cannot be expunged from the mind is like an armature, a honeycomb in whose cells each of us can place the things he wants to remember" (Italo Calvino, *Invisible Cities*, 1972): our native cities are our mnemonic theater, repositories of our individual and collective experiences. Yet just like Calvino's Zora, no city built by humanity can be "forced to remain motionless and always the same, in order to be more easily remembered." If that was the case, it would wind up languishing, disintegrat-

ing, disappearing, eventually being forgotten altogether. "The city is redundant: it repeats itself so that something will stick in the mind … it repeats signs so that the city can begin to exist." All the cities Marco Polo describes seem similar, and Kublai Khan quickly realizes that. "Traveling, you realize that differences are lost: each city takes to resembling all cities, places exchange their form, order, distances, a shapeless dust cloud invades the continents," the explorer replies.

"There is still one city of which you never speak."

Marco Polo bowed his head.

"Venice," the Khan said.

Marco smiled. "What else do you believe I have been talking to you about?"

The emperor did not turn a hair. "And yet I have never heard you mention that name."

And Polo said: "Every time I describe a city I am saying something about Venice."

"When I ask you about other cities, I want to hear about them. And about Venice, when I ask you about Venice."

"To distinguish the other cities' qualities, I must speak of a first city that remains implicit. For me it is Venice …

"Memory's images, once they are fixed in words, are erased," Polo said. "Perhaps I am afraid of losing Venice all at once, if I speak of it. Or perhaps, speaking of other cities, I have already lost it, little by little."

CHAPTER IV

Toward Chongqing

By describing a hundred real or imagined cities to the Khan, Marco Polo does nothing but reflect his image of Venice, his personal invisible city; and Calvino retreads his footsteps, forging imaginary cities built on the foundations of Venice. As he explained in a lecture at Columbia University in 1983, this was because:

> *Invisible Cities* is like a dream born out of the heart of the unlivable cities we know … The crisis of the overgrown city is the other side of the crisis of the natural world. The image of "megalopolis"—the unending, undifferentiated city which is steadily covering the surface of the earth—dominates my book, too.

Calvino suggests that Venice is the polar opposite of the "megalopolis," and that this city acts as an antidote to all shapeless cities. This is what Kublai Khan's enormous atlas—which contains descriptions of every city, all of which are described street by street—has to say:

> The catalogue of forms is endless: until every shape has found its city, new cities will continue

to be born. When the forms exhaust their variety and come apart, the end of cities begins. In the last pages of the atlas there is an outpouring of networks without beginning or end, cities in the shape of Los Angeles, in the shape of Kyoto-Osaka, without shape.

The city, the highest cultural expression produced by human civilizations, underwent unprecedented transformations over the course of the previous century. Urban dimensions have grown to exaggerated proportions, and the traditional shape of the polis has been distorted by the spread of limitless megalopolises, human anthills where tens of millions of men and women have flocked, lured by the mirage of social advancement, or merely for the chance to survive. More so than during Calvino's time, these men and women are being doomed to living conditions and schedules that bear no relationship to the spirit that gave birth to the idea and shape of the original polis; in fact, these new megalopolises actively impede people from putting civic virtues into practice and obstruct the democratic process.

Megalopolis—or the "great city"—was the name chosen by the Theban general Epaminondas for the new city he founded in Arcadia in 371 BCE as a counterweight to the power of Sparta: it numbered just a few thousand inhabitants, who had flocked to it from all parts of Greece, and this was enough to justify calling it a "great city." In a book published in 1961, the French geographer Jean Gottmann proposed using this term to refer to all the urban and suburban areas in the Boston-Washington corridor which he believed could be considered as complementary parts of a larger whole, and which he dubbed the "Northeast megalopolis." Today, the term is

used to refer to the burgeoning category of densely populated urban conglomerations which number at least twenty million inhabitants.

The concentration of a large part of humanity within increasingly expanding urban centers appears unstoppable. In the mid-nineteenth century, only 3 percent of the world's population lived in cities; yet according to a United Nations report in July 2014, this number has now risen to 54 percent, and is predicted to reach 70 percent by 2030: meaning two thirds of humanity. In 1950, only 83 cities numbered more than a million inhabitants, yet more than five hundred cities have crossed that symbolic threshold now, while fifteen metropolitan areas have more than 20 million. Among others, this category includes Tokyo (38 million), Guangzhou (32 million), Shanghai (30 million), Jakarta (26 million), and Seoul (25 million), while Delhi, Karachi, and Mexico City each have around 24 million. The city is growing at a limitless rate, especially the ones without a historic center, or in the case of China, where expediency dictated that it would be best for these to be ruthlessly destroyed, leaving only a few isolated remnants here and there. In more extreme cases, especially in Africa, the process of urbanization came part and parcel with the increasing impoverishment of those who sought a better life for themselves in the city. According to a United Nations estimate, a seventh of the global population, meaning around a billion people, currently live in shantytowns that don't even deserve to be called cities. In countries like Uganda and Ethiopia, nearly 90 percent of urban sprawl is made up of slums. A perverse continuity has established itself between the megalopolises and the shanty towns. Thus, was Isaac Asimov's ecumenopolis—the city-planet of Trantor featured in the science fiction *Foundation* series which num-

bered 40 billion inhabitants—a nightmare or a prophecy?

In this neocity, which aside from its name bears no relationship to the ancient polis, urban space is enslaved to the means of production, while the accumulation of human beings is the equivalent of swarms of termites buzzing away in a mound, the sole difference being that of the people, only some have a job, while others merely aspire to one (often in vain). The concept of the "great city" arose out of efforts to maximize the exploitation of the individual worker. After all, it was industry—or better yet, the factory, which has also experienced constant growth since the 19th century—that first triggered the densification of human populations and their dwellings, bringing about a reduction in the distance workers had to travel from their homes to their workplace and thus maximizing productivity. Between the late 18th and early 19th centuries, this grandiose project was intertwined with other epochal changes in Europe: high population growth, literacy efforts, better nutrition, medical advances, increasing consumerism, and thus a rise in living conditions. This path, forged by progress and modernity, interconnected homes and factories, industries and cities. It gave rise to the image of the city as an immense agglomeration where the individual could lose him or herself in the crowd, yet also see job opportunities and life experiences increase exponentially.

This new model of coexistence, which arose to increase the productivity of urban populaces, imposed itself on places where there were people but no factories. In the favelas, those slums on the outskirts of towns, in poverty-ravaged neighborhoods where new immigrants sought shelter, where there were no prospects for gainful employment, this void was filled by any kind of cunning, fallback trade, or criminal activity: all the ingredients of a confused hope for a better

life and social advancement. This was where the desire to be a part of the hive was born and became entrenched, to lose oneself in the masses, the herd, the certainty that one's well-being rested on one's ability to become a cog in the machine, or even just to become a part of the "modern" habitat. The irresistible allure of these new patterns of behavior created a new perception of freedom, enabling individuals to meld into the anonymity of immense crowds, focused on the two-fold ritual of production and consumption as they left behind the old lifestyle in the countryside or smaller cities, and thus this transition represented their farewell to an existence mired in poverty.

The breakneck development of the municipality of Chongqing in southwest China can usefully symbolize these dynamics. In 1930, Chongqing had six hundred thousand inhabitants, while today it has 32 million—having spiked by a further 3 million just in the past three years—amid a landscape that can only be characterized as an urban jungle of hundreds of skyscrapers: nearly thirty-two thousand square miles in area and a thriving economy chiefly centered around the automaking industry (which accounts for 18 percent of global production). The Chongqing model on the one hand provided people living in the countryside with strong incentives to relocate to the city, using state subsidies to encourage urbanization (living quarters for the young, students, and the poor), while on the other unleashing a crackdown on corruption and criminal elements. This policy, which included movements to promote Maoist-era socialist ethics (or, in other words, "red culture") was put into effect during the rule of regional Communist Party leader Bo Xilai from 2007 to 2012, but was disavowed by the central government after he was dismissed from his post for corruption and abuse of power.

While the Chongqing model emphasized the role of the state in economic and social life, the Guangdong model (named after the province which contains the city of Guangzhou) is characterized by liberal political and economic policies. Yet aside from all these differences, these largely different models of development are bound by the fact they are centered around enormous cities, since Chongqing and Guangzhou both number around 32 million inhabitants.

Will these be the sole models of urban development, the new invisible city we'll carry in our mind throughout this new century? Is it truly inevitable that every small city will be doomed to transform into a megalopolis, adding countless underground tunnels, satellite towns, highways, and other assorted forms of social alienation? Has the city of men—or rather the city built on a human scale—given way to a machine which produces and consumes, where every human being is but a cog in a giant mechanism, or a worker bee in a tireless hive? Or can we still forge a different path, come up with another narrative, another soul, and another invisible city to oppose the ruthless onslaught of the megalopolis?

Even though similar projects have failed—the ghost city of Kangbashi in Inner Mongolia being perhaps the most notable case in point—people say that the trend represented by Chongqing will ultimately triumph. Yet do we really want to think of this phenomenon as inevitable and assume it will conquer the world, supplanting all other urban forms? Or would it instead be worthwhile to keep other alternatives in mind when we think of the city of the future, analyzing its characteristics and effects on history and the notion of livability in our present times? Do we wish to nurture or destroy the multiplicity and diversity of urban forms? The transition from the historic city to the megalopolis is not a continuum, but

rather a dramatic breaking point. Venice and Chongqing are two irreducibly different models of communal living. Thus, in order to better understand and interpret Chongqing, we must inevitably think of Venice.

CHAPTER V

The Language of Skyscrapers

> The city is spreading, the city is expanding.
> A hope embellished with certainty, a kind of
> arithmetic urge, a tendency toward emulation:
> we too shall arrive at the three million of Paris,
> the four million of Berlin, the eight million of
> London, and so forth. In the acropolis and in
> the turreted provincial town councils, this civic
> itch is actually a kind of frenzy.

These words were written by the essayist and novelist
Carlo Emilio Gadda and published in the pages of the influen-
tial magazine *Civiltà delle macchine* in 1955. His prophecy still
hasn't quite come true. Rome, Italy's most populous city, has
"only" 2.7 million inhabitants, even if the wider metropolitan
region numbers around 4.2 million—but it cuts to the heart of
the problem: the "civic itch" of a municipal provincialism, the
frenzy of imitating megacities in order to undergo an upgrade
while under the spotlight of modernity. Driven by a "tem-
perament of emulation," this vain pursuit is now obsessively
focused on a specific plan: the construction of skyscrapers,
or better yet, the construction of increasingly taller skyscrap-
ers. A cheap rhetoric that sees social progress and individual
well-being reflected in the facile iconicness of skyscrapers.

It's an anxious chase, a bet placed on an upward trend, which strives to balance out the anxiety caused by the thought of falling behind in the face of an indeterminate and nebulous "foreign" threat. The passion for copying has supplanted the joy of creating, a kind of self-effacement that has turned global homogenization into a supreme value, leading to a depreciation of diversity, cultural exceptionalism, and loyalty to one's own identity.

That being said, there was no dearth of vertical construction efforts in Italy: Imperial Rome erected tenement buildings up to eight or ten stories high, which owing to the materials used (bricks and wood) were never higher than 80 to 100 feet. Examples of these residential complexes survive in Ostia Antica, and by the 2nd century ACE, writers like Juvenal were already railing against real estate speculators who plastered over deep structural cracks in their buildings despite the risk of impending collapse. The stone tower-houses built during the medieval era were even taller than their Roman predecessors and clusters of them were usually built in major cities (13th century Florence had over two hundred of them); a dozen can still be seen in San Gimignano's skyline, some as high as 180 feet. The Asinelli Tower in Bologna is 318 feet tall. Even higher were the belfries of cathedrals and the towers of city halls, which were built for defensive purposes, as well as prestige: the Torrazzo of Cremona in the 13th century is 367 feet, the Torre della Ghirlandina in Modena (12th-13th century) is 282 feet, while the Torre del Mangia in Siena was built in the 13th century next to the Palazzo Pubblico or town hall in the Piazza del Campo, Siena's premier square, and was designed to be the same height as the city's belfries to symbolize that the state and the church were equally powerful.

Towers such as these imprinted their verticality on the city like an exclamation point: placed at the forefront of the skyline, they instantly summarized it from afar, symbolically embodying its civic identity and dignity of urban life, emphasizing the prestige and form of a city (the closest we can get to this these days is by looking at cities like Orvieto, built atop a hill and still an imposing sight even though one can truly contemplate it only from the vantage point of a highway). In many Italian cities, towers, belfries and domes were built according to set municipal standards, or even simply according to common sense and civic consensus, and didn't exceed the limits placed on their heights: this was the case with the Torre del Mangia in Siena, the Ghirlandina in Modena, the dome of St. Peter's Basilica in Rome, the Madonnina statue of the Virgin Mary atop Milan's Cathedral, or the Mole Antonelliana in Turin. Of course, all of them adhere to a certain conventional size, which was never arbitrary, because it embodied (and to a large extent still embodies) a kind of ethical self-restraint, or rather the idea of a contained city with its own unique design, history, and soul. A city capable of thinking for itself. Yet this is no longer the case.

Not too long ago, a former mayor of Rome, Gianni Alemanno, declared that it was time to "break this taboo" and abolish the long-standing commitment the municipality had made that no buildings in its area could exceed the height of St. Peter's Basilica (436 feet) and further suggested "demolishing Rome's suburbs so that denser settlements could be rebuilt in their place." Yet what would be so distinctive about these skyscrapers built according to the atrocious architectural styles that today plague the Roman countryside once so beloved by Poussin and Rilke? Would they mark the beginning of a new concept of urbanity or instead form a crown of

thorns that besiege the ancient city? Would they remedy the expansion of the suburbs at the expense of the natural and historic environment, or would they instead lead to its disintegration into the confused megalopolis which might even swallow up St. Peter's itself? Alemanno cited the example of the Eurosky Tower in the EUR district, which was "designed for those who wish to live in modern, prestigious apartments with extraordinary views over Rome's skyline" and which was "inspired by the medieval towers that dot the center of the city." The heritage of Rome's historic architecture is thus exploited to threaten the historic city center itself, so that the *nouveaux riches* will be able to savor it from the heights of their apartments.

Nevertheless, what Alemanno thought was an unreasonable taboo is in fact anything but: it was a well-considered, meditated choice informed not only by a rich heritage of history and memories, but one which sought to preserve what might be called the yeast for future designs. The idea was very simple: perpetuating the spirit of the *Forma Urbis Romae* by using it as a basis for future growth, thus concatenating each new creative act and design to the city's DNA, linking it to its knowledgeable store of memories, turning architecture, as Goethe once said, into a "second Nature, one that serves civic goals." Showing respect for one's ancestors by holding posterity by the hand. Forcing architects—even the most influential ones—to adhere to rules that respect the city's ancient heritage, just like even the greatest poets pen their verses according to pre-established forms—and although a poet may well break or bend those rules, he or she can do so only by forging a dialogue with them, and not just pretending that they never existed in the first place, thus ensuring our own children will live in harmony with our heritage in

as worthy a way as our forefathers ensured in their own turn. Yet these outdated attitudes have now been supplanted by an aesthetic of excess which had made the modern skyscraper into its battle standard, by a code of ethics that has made a blind belief in the irrepressible power of the market the sole source of all value.

Against the backdrop of modernity, the architecture of skyscrapers crept onto the Italian stage on tiptoes, bearing no relationship to Roman and medieval precedents, but was instead imported, a novelty to which one was forced to adapt. Even the word itself—skyscraper—was imported, being an Anglo-American concept whose etymology originated from the "light sail at the top of a mast" on transatlantic vessels, and which in the 19th century began to be used to refer to the tallest buildings in Chicago and New York City (which were nevertheless not much taller than Roman tenements, and far lower than Medieval tower houses). The first Italian skyscraper was built in 1932 in downtown Brescia in Piazza della Vittoria, which had been completely redesigned by its architect, Marcello Piacentini, after he'd demolished an entire medieval neighborhood to do so. Piacentini's project for the Torrione (thirteen floors, 187 feet) was actually a recycled version of the bid he'd submitted to the international design competition held by the *Chicago Tribune* for its new head-quarters (now the Tribune Tower), where Piacentini's idea failed even to be short-listed. At the time, the Torrione was the tallest reinforced concrete structure in Europe, and it set the stage for more experiments in vertical building during the Fascist era, starting with the Torre Littoria in Turin (285 feet, 1934) and Piacentini's Torre in Genoa (354 feet, 1940). Ever since then, the fashion for skyscrapers has come and gone,

ebbing and flowing like a wave against Italy's shore. Here are some statistics:

	Skyscrapers built	Maximum height
1932-1940	5	354
1951-1970	13	417
1990-2000	12	423
2000-2014	28	757
Current plans & proposals	24	820

The typology of the skyscraper was occasionally adapted to historicized forms deemed suitable to Italian cities: this was the case with the Velasca Tower built by the BBPR architectural partnership in Milan (351 feet) in 1958 in an area of the city devastated by war-time bombardments. Milan, Naples, Genoa, and Turin have the highest number of skyscrapers, with Milan and Turin being the first to break the height restrictions that had been consolidated over centuries.

The former Mayor of Rome isn't the only one who thinks breaking the taboo that regulates urban growth is a sign of uninhibited modernity. In Milan, where the statue of the Virgin Mary known as the *Madonnina* atop the cathedral once marked the maximum height a building could aspire to, this barrier has been repeatedly breached in the name of progress. The first to do so was Luigi Mattioni's Torre Breda (383 feet, 1954), which was then surpassed by Gio Ponti and Pier Luigi Nervi's Pirelli Tower (416 feet, 1957), and more recently by the Palazzo Lombardia (528 feet, 2012). Yet each of these violations was offset by a ritual exorcism whereby a replica of the Duomo's Virgin Mary statue was placed atop each new record-holder, only to be shifted once

a new structure superseded it. The one placed atop the Pala-
zzo Lombardia was blessed by Cardinal Dionigi Tettamanzi
on January 31, 2010. Thus, the height restrictions weren't
simply breached, they actually produced an entirely new
rule that was completely alien to the historic city's DNA,
whereby more and more statues of the Virgin Mary were
produced, or the same copy moved from one building to
the next, as though that statue were the modern equivalent
of Saint Joseph of Cupertino's miraculous levitation. Fur-
thermore, while Milan's new skyscrapers—some of which
are under construction—will vie to surpass one another, the
statue of the Virgin Mary will either appear everywhere, or
be forced to keep flying through the air, from one perch to
the next, mocking the obsolete ban thanks to its ubiquity.

This statue, which flies from one peak to the other, chasing
Milan's construction sites, is a precedent set by the latest proj-
ect of the Venerable Factory of the Duomo of Milan: that of
transforming the ancient cathedral into a modern skyscraper,
which includes installing a 230-foot elevator tower alongside
it, which will even feature a rooftop terrace and bar. This inap-
propriate tumor on the cathedral's noble body was justified as
necessary to attract tourists and visitors to the city for its Expo
2015 world's fair, as well as to generate new income revenues.
It didn't matter much to the so-called "Venerable" Factory that
its project was opposed not only by the Ministry of Cultural
Heritage and Activities and Tourism, but also by the Church's
Code of Canon Law, which explicitly forbids the roofs of
churches from being used in a profane manner (*ad usum mere
profanum ne adhibeantur*). Nevertheless, it seems that neither
the Ambrosian Church nor the Metropolitan Archbishop of
Milan caught the slightest whiff of simony in this gross com-
mercialization of the Duomo.

And since Milan is at the forefront of breaching these height restrictions, why wouldn't Turin try to emulate its rival? The height reached by the Mole Antonelliana (550 feet), the architectural symbol of Turin now housing the National Museum of Cinema, was respected for a long time even by the Torre Littoria (1934). However the original project for Renzo Piano's hotly debated Intesa Sanpaolo Headquarters featured a skyscraper that would be approximately 650 feet tall. In the face of ensuing controversy, its height was reduced to 548 feet, meaning twenty-four inches shorter than the Mole, a laughable difference that was less a show of respect and more like a slap in the face. It is also an insult to the architectural stature and significance the Mole achieved in its time. According to Nietzsche, it was "the most brilliant work of architecture ever built," an "absolute drive into the heights," which was a sign of the "fatal destiny of heights, our fatal destiny," being one of the first modern skyscrapers, like its coeval, Louis Sullivan's Wainwright Building in St. Louis, Missouri (1890). In the meantime, the skyscraper Massimiliano Fuksas is building for the Piedmont region should reach 685 feet, or about 130 feet taller than the Mole. However, in this case there won't be a Virgin Mary statue flying from one building to another. In the name of a shallow rhetoric of modernity, the new city of skyscrapers—always looking the same whether it's situated in Rome, Naples, or Milan—has descended upon historic centers, ensnaring them and supplanting them. As architect Vittorio Gregotti said, "skyscraperism will tear apart our cities' urban morphologies."

Milan's metamorphosis into an American-style downtown, where the urban center becomes instantly recognizable by virtue of the cluster of skyscrapers—like in Los Angeles—is not the belated triumph of modernity, but merely a façade. Just like a boorish peasant putting on his best Sunday clothes

in the comedies of the past, the skyscraperly bells and whistles that Milan chose to adorn itself with for the 2015 Expo didn't highlight its success, but rather laid bare its insecurities, and was nothing but an ill-fated attempt to paper over its concerns that it had fallen behind the times, just like when someone feels unfashionable and thus hurriedly adopts tacky, foreign fads, wearing them like a mask. The historic city center is simultaneously overwhelmed and debased, to the point that we now have two urban models completely at odds with each other, but which are juxtaposed atop each other without any correlation or sense of harmony. Their adjacency is neither neutral nor innocuous, but rather functions according to a rigid hierarchy of dimensions and values. The acropolis of skyscrapers dominates the historic city from its heights, having situated itself there in a commanding position that calculatedly relegates the historic city to the sidelines. It dominates it because it is an icon of a rapidly advancing modernity and because it is branded by an expensive group of famous architects. In the end, it also dominates it chiefly because it has rendered it useless, since it no longer meets the needs of population growth—which in Italy is nil—and merely serves to transform the city into a laboratory of modernity. These are Milan's population figures, as furnished by city authorities:

1880	305,488
1920	684,234
1950	1,269,005
1960	1,521,481
1973	1,743,427 (maximum value)
1983	1,561,438 (more or less like in 1960)
2003	1,271,898 (more or less like in 1955)
2012	1,262,101 (more or less like in 1949)

As we can see, Milan has lost half a million inhabitants over the last forty years, compared with the density it achieved during the boom years and the period of vast internal migrations. Notwithstanding the above, the municipal town planning program approved in 2011 by the administration of then Mayor Letizia Moratti predicted a constantly growing population, expecting it to rise to 1,787,637 by 2030, which is nevertheless barely more than the city had in 1973. This arbitrary outlook completely disregards all economic forecasts, population movements, or the very attractiveness of that urban area: yet it sufficed to launch the new initiative *Milano per scelta*, or "Milan makes its own choice":

> which is inspired by David Cameron's concept of the big society, meaning a society that builds itself, where state and local authorities exercise less influence and the private sector assumes a stronger role, even in the public and social spheres.

Thus, the program foresaw "7 million square meters [75 million square feet] of land zoned for building purposes, which would involve 18 million cubic meters [over half a billion cubic feet] of concrete and the construction of 26 new neighborhoods." As the art historian and senator Giulio Carlo Argan noted in an effective statement he made before the Italian Senate in 1990, the Italians "have no love for budgetary estimates, but rather prophecies when it comes to spending." So we grin and bear it.

It is therefore assumed that the mere existence of skyscrapers will lure people and prosperity to Milan—drawing

them like flies to honey—when the city has actually been steadily losing its inhabitants, taking this fiction for granted, as though Milan were on the cusp of some great economic boom; yet the sole boom the city witnessed was reaped by those who profited from the waste and corruption denounced by the judiciary. As is the case in Milan, the typology of the skyscraper is imposing itself on all other Italian cities in a manner that completely ignores population projections and any notion of town planning. It only obeys the sociocultural need to display a successful model of a city in order to keep up with events unfolding elsewhere. Yet which set of examples is skyscraper-obsessed Italy following today? Those set by New York City or Chicago, where the phenomenon of skyscrapers arose just over a hundred years ago? Or has it instead turned its sights to Chongqing, Abu Dhabi, Singapore, or Dubai?

Has Venice been spared this trend, or will it too be overwhelmed by it? Will skyscrapers really revive a rapidly depopulating city, a city made up of belfries, islands, canals, and bridges set along a lagoon? Will this trend be the gateway to the city's long hoped for "modernity"?

CHAPTER VI

The Forma Urbis: Aesthetic Redemption

If a skyscraper ever towers over Venice, there will be need for those who will readily proclaim its beauty. But the introduction of skyscrapers to a historic city cannot be just a panacea deployed to achieve a belated modernity: they must be redeemed by using an alibi to detract attention from their economically motivated real estate speculation and the social problems left in their wake, shifting the emphasis to aesthetic, technological, or ecological values. This new wave of skyscrapers can vary greatly depending on their context. Sometimes skyscrapers are merely added to the skylines of cities that already have plenty of them, like New York City or Chicago, or even Chongqing and Dubai, which mushroomed in recent years by dedicating themselves to this sort of structure. Sometimes, however, a single skyscraper bursts onto the scene out of nowhere, tearing through a city's historic fabric: this was the case with César Pelli's towers in Seville, Spain and Santiago, Chile. The Cajasol Tower in Seville is 590 feet tall, or 249 feet higher than the Giralda, the marvelous bell tower that was formerly a minaret attached to the city's cathedral. The signature building of one of the world's most famous architects, the Cajasol Tower is the best contemporary example of how any distinctions between delicately constructed historic city centers, like Seville's, and relatively new cities, like Santiago,

can be completely eliminated. Cheapside Street in London offers another example, where not one but many skyscrapers distorted an area of functional and historic importance, leading Christopher Wren's St. Paul's Cathedral to be dwarfed by a jungle of high-rises built according to a heterogeneous mix of styles and materials which increased real estate income at the expense of history. The proliferation of skyscrapers is occasionally justified by the need to accommodate more people within a limited area. This is very much the case with Hong Kong, which has a population density of thirty-seven thousand per square mile, dozens of times denser than Rome. In other cases, skyscrapers were merely used to shore up a city's claim to its own modernity, and to try to catch up to the United States, where this typology first originated. This is exactly what happened with the Seven Sisters in Moscow—which Muscovites informally refer to as "Stalin's High-Rises"—constructed at the height of the Cold War, or as occurred in fascist Italy or Spain, or what is happening today in China or the Persian Gulf states.

The densification and verticalization of the city thus proceeds uninhibited, imposing itself as though it were the only conceivable model for the conurbations of the future. Three converging factors have contributed to this: the concentration of the workforce and the social control measures that this requires, speculation on lands deemed suitable for construction purposes which can therefore maximize an area's real estate potential, and finally the development of increasingly sophisticated technologies and the desire to show off a city's success by building increasingly taller high-rises. The spectacular destruction of the Twin Towers in New York on September 11, 2001 marked an important turning point in this narrative because the target selected by terrorists embodied the United

States's economic might, but also because its collapse helped to both renew and strengthen the role played by skyscrapers as the supreme icons of success and modernity. As a result, the dizzying acceleration of technological advancement has now led to a veritable race to build the tallest skyscraper in the world, which has now shifted from the United States to China and the Arab world. These figures omit spires and rooftop antennas:

1870	New York	Equitable Life Building	141ft
1889	Chicago	Auditorium Building	269
1901	Philadelphia	City Hall	511
1931	New York	Empire State Building	1250
1972	New York	Twin Towers	1368
1974	Chicago	Willis Tower	1450
1998	Kuala Lumpur	Petronas Towers	1482
2004	Taipei	Taipei 101	1505
2008	Shanghai	Financial Center	1597
2010	Mecca	Abraj Al-Bait	1971
2010	Dubai	Burj Khalifa	2716
2018	Jeddah	Kingdom Tower	3303

Other skyscrapers currently under construction (a selection):

China	Shenzhen	Ping'an Finance Center	2165
	Wuhan	Greenland Center	2086
	Shanghai	Shanghai Tower	2073
South Korea	Seoul	World Premium Tower	1820
	Busan	Busan Tower	1673
	Songdo	Incheon Tower	1597
India	Mumbai	India Tower	2362
Russia	Moscow	Federation Tower	1669
North Korea	Pyongyang	Ryugyong Hotel	1082

The names given to some of these high-rises reveal a desire to create a landmark that the entire nation can identify with (India Tower) or affirm its political structure (Kingdom Tower, Federation Tower). The construction of skyscrapers is rapidly intensifying: thirty-two buildings over two hundred meters, or 656 feet, were built in 2005, and eighty-eight were built in 2011. In 2012, the jury of the Emporis Skyscraper Award (which was first awarded in 2000) received three hundred nominations and eventually bestowed first place to the Absolute World Towers in Mississauga, close to Toronto.

The race to build the tallest skyscraper in the world is but the beginning. In 1956, Frank Lloyd Wright published his vision for a mile-high skyscraper for Chicago that would be called The Illinois. Saudi Arabia's Kingdom Tower in Jeddah is but the continuation of that project, and it also aimed to be a mile high before settling for a mere kilometer. Yet Wright himself had proposed a horizontal city of single-family homes in his book *The Disappearing City* (1932), theorizing a model of suburban development he called Broadacre City, where each family would be given a one acre plot of land. Nice, round figures (a mile, a kilometer) have both exclamatory and rhetorical value. The Corviale housing project in Rome, "a kilometer in length," is a good example length-wise, but when this concept becomes vertical, its meaning changes quite entirely, because it embodies humanity's pride in overcoming obstacles and sets a limit we desire to breach. As it happens, quite a few kilometer-high skyscrapers are currently being planned in Kuwait (Burj Mubarak al-Kabir, whose height of 1,001 meters (3,284 feet) was selected to echo *The One Thousand and One Nights*), as well as in Dubai, Miami, and Tokyo. Shanghai's Bionic Tower is set to reach 1,228 meters (4,029 feet), while the Millennium Challenge Tower, whose planned height will reach a

nautical mile (or 6,076 feet), has been envisioned by an Italian architect for a potential Kuwaiti client. Does this mean we will soon build skyscrapers that are one, two, three miles tall, purely in the name of competition for competition's sake?

In a working paper published in 2010 by the National Bureau of Economic Research in Cambridge, Massachusetts, William Goetzmann and Frank Newman argued that the high-rises of New York's skyline "represented more than an architectural movement; they were largely the manifestation of a widespread financial phenomenon," and mirror stock market speculation and increased demand for real estate investment, nevertheless failing to take into account that while "optimism in financial markets has the power to raise steel, it does not make a building pay." (In fact, skyscrapers often remain empty for years, a case in point being the Tower of David, an unfinished skyscraper in Caracas whose forty-five stories had been destined to host a financial center, but which is now home to three thousand squatters and is referred to as "the world's tallest slum.") It's no coincidence that the histogram of skyscrapers built in New York City between 1890 and 2010 closely resembles the average modern city's skyline:

A capitalistic fetish even in its Chinese incarnation, the skyscraper is instantly replicable on a global scale regardless of the local context, and it has become the architectural face of a triumphant neoliberalism, indeed is the symbol—and not just in a metaphorical sense—of a civilization completely subservient to market forces. A market that makes money out of money and not through the production of actual goods, and where wealth is concentrated in very few hands, safely sheltered from the reach of the law and democracy, is the central dogma of neoliberalism. The gigantism of skyscrapers completely plays into this and is the perfect embodiment of the inequality between those who build and own those structures (meaning the 1 percent, to borrow from the language of the Occupy Movement) and those who instead live or work in them (the other 99 percent).

The economic rationale and social consequences of this new architecture of skyscrapers are being systematically concealed and obfuscated as though this new urban model were simply the result of invisible laws of nature. The most basic question we must ask ourselves, namely whether it is better to live in a horizontal city or a vertical one, is sometimes pushed aside by the hackneyed rhetoric of competitiveness, or by notions of technological or aesthetic redemption, starting with the construction of structures and shapes that seem to defy the law of inertia, not only because of their height, but also because of their appearance. Tower 1 of the Absolute World complex in Mississauga, Ontario is 590 feet tall and has fifty-six oval-shaped floors, which rotate in a range of one to eight degrees at each successive level, for a total cumulative floor plate rotation of 209 degrees. This sinuous shape (labeled "voluptuous" in internal design documents) led to the complex being informally referred to as the Marilyn Monroe

Towers. Nevertheless, by 1995 Santiago Calatrava had already built his Turning Torso in Malmö, Sweden, which was composed of five-story pentagons that twist relative to one another as they rise, providing fifty-four floors of apartments. Thus, in both Sweden and Canada, the inhumanity of skyscrapers is redeemed by anthropomorphizing them, pretending that their shape is actually modeled after that of the human body.

Similarly, César Pelli's towers in Seville and Santiago have often been referred to as gigantic phallic symbols. This widespread metaphor reveals how architecture is conceived as a form of control, oppression, and display of power, typical of an androcentric society in which rape can be considered a virtue. The skyscraper is the dominant male that forces the city, or the woman, into submissiveness; or the skyscraper, which represents modernity, fertilizes the historic city center; the vertical city versus the horizontal city. The rhetoric of heights, whereby the competitiveness of the financial markets has infected the notion of architecture, means that even a cluster of skyscrapers does not constitute a sufficiently impressive landmark unless one of them dwarfs the others. The new skyscraper must *dwarf* all other structures beside it, the press releases issued by architectural firms, construction companies, and city authorities seem to say. Dwarfing of course here means to tower above something, even though the etymology tells us that the primary meaning is "to make dwarf or dwarfish; or prevent the due development of"—yet another anthropomorphic metaphor that roots the muscular, authoritarian vision of contemporary architecture in everyday language, where the big always triumph over the small, the rich triumph over the poor, and the new triumphs over the old. The victory of technology is celebrated, while the power of money is concealed in the shadows, yet they are both sides of the same coin, the

deeply layered metaphor of how markets completely dominate our society.

Aesthetics, technology, and ecology, which are so often intertwined, provide the conceptual framework to advertise this new architecture of heights. Curvy, bendy skyscrapers are being planned and built all over the world in a crescendo of "dynamic architecture," leaning this way or that like the Tower of Pisa, ever taller towers that look as though they might collapse at any moment; skyscrapers built in the shape of vegetables, shells, like the tentacles of giant octopi, or colossal eggs, or incredibly sharp needles that pierce the clouds, gargantuan crystal shards, or the sails of impossibly shaped ships, or cubes and spheres stacked atop one another, or even like humongous knives. The Aqua Tower in Chicago (eighty-two floors, 860 feet tall) is made up of irregularly shaped floors, giving it an undulating, striated façade that mimics the surface of water, albeit in a vertical manner. A comparable evolution is at work in museum architecture, such as Frank Gehry's Guggenheim Museum Bilbao, another example of where an architectural structure is conceived of as a gigantic sculpture to be admired from afar—called scul-chitecture by art critic James Hall—giving a structure such a peculiar shape that the building becomes an instant landmark of the city where it is located and consequently one of the architect's signature pieces. Even the three new skyscrapers of the CityLife complex in Milan—informally referred to by locals as "the upright," "the crooked," and "the hunchback"—are based on these new designs, and they too adopted metaphors inspired by the human body.

Having become a self-contained vertical city with thousands of inhabitants, the average modern skyscraper tends to be divided into various functional areas, with restaurants, shops, apartments, offices, amenities, elevators, and subway

entrances, gardens, tree-lined squares, all equipped with new technologies to produce clean energy. Not to mention how, echoing the advertising slogans, those living in the upper floors will be able to breathe fresh air, thus freeing themselves from giving a damn about pollution (so long as they pay the right price). The ecological alibi is a driving force in the skyscraper's dissemination; in fact, one now speaks of "eco-skyscrapers" or "eco-towers." In Japan, two colossal vertical cities inspired by these concepts were planned: Holonic Tower and Sky City, which were to be 3,280 feet tall and house thirty-six thousand full-time residents, as well as provide work for one hundred thousand commuters. Buildings such as these, arranged in clusters, are designed to contain green spaces in between the structures, which are useful for Sunday walks. The term "urban forest," another of these metaphors, is employed to describe both the agglomeration of skyscrapers in these new megalopolises—as in the case of Chongqing—as well as the woods and gardens interspersed between them.

The adoption of organic shapes, anthropomorphic metaphors, ecological benefits, hanging gardens, and the creation of "villages" and "neighborhoods," all point to the same intent: the aesthetic redemption of the skyscraper as an urban form. Names, structures, shapes, and functions are being manipulated to obfuscate the violence being perpetrated not only on our environment, but also against the very culture of the city itself. Enormous spaces destined to swallow up tens of thousands of men and women are thus made to seem innocuous—or better yet, even "voluptuous" and pleasant, exploiting nicknames to make them sound like inoffensive, ordinary people, just like you and me. Necessary concerns such as living conditions for its citizens or the requisite financial apparatuses are banished in the name of an abstract modernity that either

doesn't know, or doesn't wish to know, how to strike a compromise on issues such as equality, democracy, or "good living."

Long absent in this race toward gigantism, Italy seems to have thrown itself headfirst into a ruinous attempt to catch up, seeking to satisfy its provincial urge to modernize itself—"this civic itch," the author Carlo Emilio Gadda might have said—believing the skyscraper to be the skeleton key of modernity, redeeming a country where people say that too few modern structures are built. Of course forgetting that there has been plenty—if not too much—modern architecture to be seen in the country over the past sixty years; for instance the squalid suburbs that encircle most cities, the result of a corrupt, short-sighted politics and the horrible degradation of taste that architects and engineers have succumbed to, a phenomenon that has now affected the whole country, which once upon a time reached incredibly high levels of architectural creativity, and which it also exported all over the world. Skyscrapers won't "repair the peripheries," as Renzo Piano's operative slogan claims; instead, the real solution, should we wish to employ it, will be to rebuild a kind of urban life that restores the harmony between the concepts of city and citizenship. However, our contemporary race to build skyscrapers devalues and supplants the historic city, undermining the central role it plays in our mind, forcing the invisible city inside us to metastasize in unprecedented ways. Even before the first skyscraper had been built, or planned, or dreamed, the idea of the vertical city as being inseparable from our vision of modernity has always been taken for granted, eating away at the ancient *forma urbis* by degrading it to the symbolic relic of a remote past which has to be vanquished by towering above it, or better yet lording over it, thereby looking down on St. Peter's Basilica and the Mole Antonelliana, and all the cathedrals and bell towers,

or as the poet Giacomo Leopardi put it, the "ramparts and the arches / and the columns and the statues / and lonely towers of our ancestors." Even in Venice.

If modernity cannot exist without skyscrapers, then Venice will eventually have to adapt one way or the other and comply. This must have been the sort of rationale that inspired the Aqualta 2060 project which debuted at the 2010 Venice Biennale and which was conceived by the Belgian architect Julien De Smedt and his studio, JDS. The idea was to save Venice from rising water levels by surrounding it with a ring of skyscrapers built atop artificial islands that would act as a dam and repopulate the city with actual Venetians. As the studio's website says, in not entirely correct English:

> When looking at a not so distant future, we have a few certainties: sea level will raise and global warming will affect climate. Aqualta is an attempt to describe this scenario: how to protect the city from the sea? What if we consider to build a new edge, a linear city emerging from the water around Venice: a new frame, and a new perspective toward Venice to preserve and enjoy the historical city. How does this city looks like? It is a long waterfront stretching in front of Venice: and if the weather is warmer, why not thinking of it as the Italian Copacapana, a long beach submerged by tropical vegetation. A vision of a vision: the old Venice overlooking over the bay of Ipanema; from the new town beaches and houses will have the glorious backdrop of an unseen Venice!

Is this provocative or prophetic? Regardless of its intentions, this text has two significant implications: on the one hand, it wishes to rip Venice out of its historical and geographic context, comparing it to other regions of the world, albeit playfully, looking at it as though it were a fashionable suburb of Rio de Janeiro. On the other hand, it looks at Venice as a city that shouldn't be lived in, but merely admired from afar, treating it as though it were some panorama (like a painting, or a postcard, or even a TV commercial) rather than a living and breathing community made of men and women. Thus, in order to enjoy looking at what is actually a historic city, one must first reenvision it as a "glorious backdrop," to be enjoyed by those who will in fact live far removed from it inside their skyscrapers, although they might perhaps admire it during the course of a Sunday outing. The Venetians who will remain in the city will therefore be reduced to the role of fish inside an aquarium, eyed through binoculars from the heights of its surrounding high-rises. One might as well force them to wear wigs and petticoats as though they were characters in some theme park, or even ghosts. Just as often occurs in the aftermaths of plagues, wars, and earthquakes, there are those who profit from catastrophes: even global warming can be a disaster with fortunate consequences, at least for those who think it would be a good idea to build a Venice made of skyscrapers where the same sort of people who frequent the beaches of Copacabana will be able to feel at ease, as was the case with JDS's Venice 2.0 (interestingly, the project leader is an Italian architect trained in Venice).

A paradoxical continuum runs through this and other Venetian metamorphoses: that the city's uniqueness is a thorn in the side of a two-bit modernity, the prime example of a stale

and intolerable forma urbis, whose mere survival is a provocative challenge that must be met, forcing Venice to assimilate until it looks like any other city. This is the reason why it has become a laboratory for theoretical experiments—such as Venice 2.0—which defile its history and soul while pretending to revitalize its moribund body, like a physician who kindly rushes to a sick man's bedside only to give his patient a lethal drug. Let us therefore ask ourselves the following question: Can Venice's uniqueness (being one of the only cities on earth where the sound of one's footsteps isn't drowned out by the rumble of traffic, where one can still hear the sound of the water washing against the quays and the "stones of Venice," which Ruskin so dutifully explored) still be considered an antidote to the monoculture of skyscrapers?

In Italy, the virile rhetoric of monuments, whereby a structure is meant to symbolize authority and the will to power, should instantly evoke Benito Mussolini's pompous speech of December 31, 1925, when he proclaimed: "The eternal monuments of our history must be allowed to tower in their necessary solitary grandeur." He was proposing artificially isolating the Roman ruins in order to force them to stand as witnesses not to the glories of the old empire, but to the new empire he sought to build. Despite appearances to the contrary, a silent kinship links this kind of discourse and manipulation of ancient heritage to the rhetoric of the modern skyscraper, which devours historic city centers by looking down on them from above. Venice is not safe from dangerous fantasies: Pierre Cardin, the fashion designer (whose family hails from the Veneto and who was born there) drew up plans for a futuristic skyscraper to be built in the industrial area of Marghera called the Palais Lumière, a mastodonic structure 820 feet tall. Unlike Aqualta, a trial balloon designed to gauge

public opinion on conquering Venice's historic city center, Cardin's plan was even considered beautiful by some because it had been conceived by a great fashion designer, and the plan was launched amid a media campaign that depicted his skyscraper as a means to inject life into a moribund city. The Cardin project, launched in 2012, has since been scrapped amid great controversy. But could Venice eventually be surrounded by a ring of skyscrapers, as envisioned in Aqualta, or will its historic center be dwarfed by a single high-rise, turning the former into an old dwarf who gets stared down by a young, muscled giant?

CHAPTER VII

How Much Is Venice Worth?

What would Venice's market value be if it were put up for sale? Although one can hardly imagine a more grotesque or idiotic question, this has become a topical subject in Italy, and not just in the case of Venice. Thanks to a legislative decree passed by the government in 2010, a provision on so-called "federal property" signed into law by then Prime Minister Silvio Berlusconi and Roberto Calderoli, who served as minister responsible for legislative reforms—and was supported by Italy's other "founding fathers" like Giulio Tremonti, Umberto Bossi, Roberto Maroni, Renato Brunetta, and Raffaele Fitto—the *Official Gazette of the Italian Republic* and the Agenzia del Demanio (Italian Public Property Agency) have shamelessly begun to publish lists of public heritage sites alongside their respective price tags. Seventy-five properties in the Venice municipality alone were included, among them:

La Certosa Island	€ 28,854,000
Batteria Daniele Manin	3,885,276
Morosini Fort on the Lido	1,936,340
Caserma di cavalleria	1,719,864
State Archives, Campo San Bartolomeo	1,198,702
Fabbricato urbano, Santa Croce	900,000
former Casa del Fascio	461,740

One can hardly read the 536 pages constituting this list without losing one's mind (a second list, published on May 13, 2011 ran to 720 pages). We are now thus able to know that the Monte Cristallo in Cortina d'Ampezzo is worth 1,474,262.92 euros, but not a cent more; or that the Nicolò Machiavelli high school in Lucca is worth 1,417,702 euros; or that the headquarters of the *Genio Civile* or civilian engineers in Naples is valued at 14,978,541 euros; and so on and so forth. Thanks to the Calderoli Act, public heritage sites that once belonged to all Italians are now the exclusive property of individual city governments, thereby literally stealing them from everyone else. In the words of historian and journalist Ernesto Galli della Loggia, we have therefore become "Italians without an Italy" in complete violation of the Constitution. A recent case in point was the attempt to sell Venice's Poveglia Island in the Lagoon between Venice and the Lido, which was eventually thwarted despite a 513,000-euro offer made by a private entrepreneur that sparked an effort to raise funds to ensure it would be kept open to the public.

One might well argue that the ridiculous sums we've seen so far are nothing but rough estimates arbitrarily set in order to calculate an inventory value and thus enable the transfer of public assets held by the state to individual city governments. Yet this isn't the case: indeed, once the transfer of ownership has taken place, the majority of these assets and heritage sites become instantly available for sale to private interests and investors. In fact, the Calderoli Act also allows for city governments to literally give these properties away to privately-held real estate funds; furthermore, city authorities are being encouraged in every possible way to sell off their patrimony, to the point that another law requires them to furnish a yearly report on their "real estate disposals" alongside their

budgets. Thus, Paolo Maddalena, Judge Emeritus of the Italian Supreme Court, was quite right when he wrote,

> the minds of our elected representatives have been clouded by theories that prize the value of money, and the counting of that money, while remaining indifferent to the fate of individual citizens, civic institutions or our country as a whole ... These legislative measures are exceptionally worrisome, and they run counter to the laws and spirit of our Constitution, in fact breaching nine articles in a single stroke.

This minutious calculation of value has turned Italy into a gigantic real estate supermarket, where anyone who can afford it can turn up with a shopping cart and pick out buildings or landscapes they like and just snap them up. We simply cannot shrug off such cultural regression unfolding before our very eyes, especially when it bears our institutions' seal of approval. The fact that the Ministry of Economy and Finance and the Italian Public Property Agency are literally putting a price tag on every mountain, school, or barracks is neither innocent nor harmless, since these bodies have been constitutionally charged with protecting public property. Yet the very agencies that should be safeguarding it have actually been contributing to the process of dismantling the state—which has been going on for two decades now—betraying it with impunity, transforming themselves from the custodians of public assets into the standard-bearers of private interests. It may well be that Monte Cristallo and La Certosa island are never sold, but this will probably have more to do with their being too expensive and the fact that they aren't a great source of revenue rather

than because they belong to all Italian citizens; nevertheless, the mere act of attaching a price tag to them, and cheerfully spreading the news through a website, has broken down the barrier between the state's inalienable right to own these properties (an essential attribute of popular sovereignty) and salable commodities, thus trampling on the Constitution, the public interest, and the country's history.

Yet the habit of putting a dollar sign on everything doesn't stop there. In a news story first broken by the *Financial Times* in 2014, which was then reported by all Italian dailies, Italy's auditor general, the Corte dei Conti, threatened to sue the credit rating agency Standard & Poor's over its decision to downgrade Italy's credit rating without taking its historical and cultural treasures into account.

Corriere della Sera wrote on February 5, 2014: "How much are the *Divine Comedy, La Dolce Vita* or Michelangelo's Sistine Chapel worth in relation to the public budget? What sort of role should Italy's immense historic, artistic and literary heritage, which was accumulated over the course of millennia, play in determining the country's wealth? According to the auditor general, it should heavily influence a country's credit rating."

Such was the argumentation behind the plan to sue S&P for 234 billion euros. Is this a fair estimate of the country's culture and total market value? Does it really account for every inch of the country's landscapes, every cathedral, every word of the Italian language, every panorama seen from the Alps, every painting displayed in the Uffizi Gallery, every stanza put to paper by Ariosto, every Antonioni film? Does this sum also include the value of every Italian citizen?

Analyzing every aspect of that bizarre news story—the denials, counter-denials, pundits' comments and the oblivion to which it was all rapidly consigned— hardly matters

here: what is truly important is that this kind of cost-account-
ing was actually taken seriously. In an interview given to *La
Repubblica*, the economist Paolo Leon was very adamant on
the subject: "Figuring out how much the Colosseum is worth
is quite easy, it's already been done, but quantifying the value
of Dante Alighieri is far more difficult," given that "credit
scoring agencies are only interested in the market value of an
asset's usability." Citing the well-preserved Renaissance walls
of Ferrara, he furnishes us with an example:

> We've worked out how much space those walls
> take up, thus restricting the available amount
> of space the city has to expand: the missed
> opportunities in real estate speculation, if in-
> dex-linked through the centuries, together with
> the intrinsic beauty of Ferrara's walls, can give
> us an approximate idea of what they are worth,
> as well as allow us to better understand their
> importance and how best to preserve them.

Given that this was printed in one of Italy's leading news-
papers, let's look at this argument from a literal point of view:
one could deduce from it that whether a public asset should
be protected depends on the market value of the land where
it is situated, which doesn't take into account the value of the
buildings constructed on top of it, or their "intrinsic beauty."
Of course, nothing of the sort ever crossed the minds of Ita-
ly's legislators when the Constituent Assembly discussed and
finally approved Article 9 of the Constitution: "The Republic
promotes the development of culture and scientific and tech-
nical research. It safeguards the natural landscape and the
historical and artistic heritage of the nation."

But apparently the walls of Ferrara (as well as those of Lucca, or the piazzas of Turin, Florence, and Palermo) have been "restricting the available amount of space the city has to expand." In other words, the most natural use of land is real estate speculation, which could turn a profit today or tomorrow, whereas the existence of buildings that were constructed yesterday but are still valuable doesn't actually matter, since they end up "restricting the available amount of space" and therefore limiting income (but what if that part of town was valuable precisely because it is in the vicinity of those walls?). Consequently, in the case of Venice, one must work out the value of St. Mark's Basilica by calculating the amount of space it takes up, which could otherwise be used to build a skyscraper. Or if the Colosseum in Rome were worth only what the land would be valued at if a high-rise were built in its place. Or if the archaeological site at Pompeii would be only as valuable as land on which it stands, so that Mafia kingpins and their construction companies could get rid of all those archeological ruins and build slums upon slums in their place. This, then, is what Venice is worth: the labyrinth of islands on which it is built is only as valuable as the land would be, were it made available to real estate speculators. Can anyone work out exactly how much this would be? It's certainly possible, and since we're all so obsessed with putting a price tag on everything, it's quite likely that someone, somewhere has already figured it out. Such is our inability to understand that there are some things money can't—or shouldn't—buy, because they are quite simply priceless. And that cities aren't just the physical sum of walls, houses, and churches, but that there are invisible cities which can't exist without those very walls, houses, and churches. In Venice's case, also bridges and canals.

Is it really possible, wise, or commendable to pile the Colosseum, Tintoretto, *La Dolce Vita*, Machiavelli, Bernini, and *La Traviata* into the same shopping cart? We have the right to ask those who dwell on discussing how much they are worth for explanations. For a start, the Sistine Chapel is out: if anything, it will be chiefly useful in working out the Vatican's creditworthiness. But to return to Italy, how much is Caravaggio worth (and I don't mean just one of his paintings)? How exactly does one put a price tag on Dante or Petrarch? And what about the Roman Empire—how does one estimate its value? Not to mention the other fruits of Italian creativity, from sonnets to pianos, and from lyric opera to the papacy (should one include the Mafia too?). Or Galileo, Volta, and Marconi? What is "the market value of an asset's usability" when it comes to *The Aeneid* or *The Decameron*? We've trained ourselves far too well to monetize everything by repeating that boring mantra of "oil reserves," demoting our cultural heritage to that of a reservoir which we empty in order to cash in, leaving nothing behind for future generations. Yet our cultural heritage has nothing to do with oil; it's the very air that we breathe, the blood that flows through our veins, the flesh of which our bodies are made of. Article 9 of the Constitution explicitly refers to safeguarding "the artistic heritage of the Nation"—in other words the repository of individual histories and memories—for the benefit of its citizens. One cannot put a price on that, and the 234 billion euros demanded from S&P wouldn't cover a single tercet of Dante's poetry (or Homer's, or Shakespeare's), or a single one of Rossini's notes, or a single one of Raphael's brushstrokes. Simply because the real value of one of Dante's tercets lies not only in its relationship to the other sections of the *Divine Comedy*, but is also to be found in its ties to the very history of Florence, Italy, and Europe—

right up to the present day. Any price a speculative market would set on this intricate fabric of artistic and social relationships would be nothing short of an obscene lie.

We should counter the approximations of self-styled appraisers with the seriously pondered reflections of others on the true value of cultural heritage. One need only cross the Alps and head into France. A report entitled *The Economy of the Immaterial: The Growth of Tomorrow*, which was drawn up by Maurice Lévy and Jean-Pierre Jouyet, reflects on immaterial values (meaning priceless ones) as the basis of all future growth. It begins: "We possess a single, inexhaustible source of wealth that can fuel future development and prosperity: the talents and passions of men and women." Talent and passion triggered and nurtured by our cultural memory. The report was commissioned by the French Ministry of the Economy in 2006 under the presidency of Jacques Chirac and concluded that immaterial values are "concealing a huge potential for growth, which can stimulate the French economy by generating hundreds of thousands of jobs, while simultaneously preserving others that would otherwise be put at risk."

No Italian Minister of the Economy—nor for that matter, any Minister of Cultural Heritage—has ever employed words like these; in fact, no high-ranking government official of any kind in Italy has ever tried to even meekly defend the true immaterial value of our cultural heritage.

Venice is priceless: the invisible city has seeped into every stone of its paths and bridges, and every drop of water in its canals, forming a dense network of connections, a powerful web of facts and actions, memories and words, beauty and history. Yet Venice is now threatened by what John Maynard Keynes once termed the "parody of an accountant's nightmare," in other words the abject, prejudiced view that

everything should have a price tag, or better yet, that money is the only thing that matters:

> Instead of using their vastly increased material and technical resources to build a wonder city, the men of the nineteenth century built slums; and they thought it right and advisable to build slums because slums, on the test of private enterprise, "paid," whereas the wonder city would, they thought, have been an act of foolish extravagance, which would, in the imbecile idiom of the financial fashion, have "mortgaged the future"—though how the construction to-day of great and glorious works can impoverish the future, no man can see until his mind is beset by false analogies from an irrelevant accountancy. Even to-day I spend my time—half vainly, but also, I must admit, half successfully—in trying to persuade my countrymen that the nation as a whole will assuredly be richer if unemployed men and machines are used to build much needed houses than if they are supported in idleness. For the minds of this generation are still so beclouded by bogus calculations that they distrust conclusions which should be obvious, out of a reliance on a system of financial accounting which casts doubt on whether such an operation will "pay." We have to remain poor because it does not "pay" to be rich. We have to live in hovels, not because we cannot build palaces but because we cannot "afford" them.

The same rule of self-destructive financial calculation governs every walk of life. We destroy the beauty of the countryside because the unappropriated splendors of nature have no economic value. We are capable of shutting off the sun and the stars because they do not pay a dividend.

What if the wonder city envisioned by Keynes already existed? What if its name was Venice? Or what if Venice could become such a city?

CHAPTER VIII

The Paradox of Conservation, the Poetics of Reutilization

During Roman times, Athens jealously guarded the ship of Theseus, the one the mythological hero used on his return from Crete after defeating the Minotaur, yet as the ancient wood slowly deteriorated over time, new planks of wood were installed to replace the old. Thus, as Plutarch tells us in his *Life of Theseus*, the ship "became a standing illustration for the philosophers in the mooted question of growth, some declaring that it remained the same, others that it was not the same vessel." The visible, tangible ship always changes, and its planks are continually replaced, but it nevertheless remains the same, since if every new plank is essentially the same as the old one, the intangible wholeness is not actually altered. This is the paradox of conservation according to the Eastern model best exemplified by the Ise Grand Shrine in Mie Prefecture, Japan, which has been routinely demolished and rebuilt every twenty years at least since the 7th century, and yet each time a structurally meaningless column is left standing from its previous incarnation when the shrine is rebuilt. As Robert Singer, the Japanese art curator at the Los Angeles County Museum of Art, once commented when he kindly acted as my guide during a visit to Japan, "the oldest temple in Japan never goes over the age of twenty." The working temple is built on a single

platform, and the empty site beside the shrine is both where the previous temple once stood and also where the next will be built: a clear expression of the balance between full and empty, continuity and discontinuity, reflecting the Shinto belief in the perpetual renewal of nature and man as well as a means to pass building techniques from one generation to the next. The current temple was built in 2013, while the next will be built in 2033. In Japanese culture—or even Chinese and Indian culture—authenticity has nothing to do with the materiality of an object or building, but is rather defined by its formal truth. Discussing a similar paradox in his *A Treatise of Human Nature*, David Hume compares one's identity to:

> a church, which was formerly of brick, fell to ruin, and that the parish rebuilt the same church of free-stone, and according to modern architecture. Here neither the form nor the materials are the same, nor is there anything common to the two objects, but their relation to the inhabitants of the parish: and yet this alone is sufficient to make us denominate them the same.

We might say that they are based on a truth function—and what can be said of a person or a building, can be said of an entire city:

> A city, like a living thing, is a united and continuous whole. This does not cease to be itself as it changes in growing older, nor does it become one thing after another with the lapse of time, but is always at one with its former self in feeling and identity, and must take all blame or

credit for what it does or has done in its public character, so long as the association that creates it and binds it together with interwoven strands preserves it as a unity. To create a multiplicity, or rather an infinity, of cities by chronological distinctions is like creating many men out of one because the man is now old, but was in his prime before, and yet earlier was a lad. (Plutarch, *On the Delays of the Divine Vengeance*)

The tangible appearance and intangible form change at the same time, remaining equal to themselves, regardless of whether it's a Japanese temple or an English church. The city retains its soul, its continuity, right up to the moment when the community that dwells in it considers itself the heir of its own traditions.

The paradox of conservation is that nothing can ever be truly preserved nor handed down if it remains static and stagnant. Even tradition is an act of perpetual renewal, and if this necessary, constant motion should ever stop, it would exact an incredibly high price: death. However, renewal does not automatically lead to (self) destruction: neither conservation nor tradition was responsible for the demise of Carthage or Tenochtitlán—both those cities met a violent death. No metaphor more appropriately fits the city than the one fashioned by Plutarch: the city is like a living organism, which grows as it mutates and yet still remains itself, in accordance with its DNA—to employ language more familiar to us today—which is inscribed in its own history, in the uniqueness of its *forma urbis*. The soul of the city—the invisible city—which manifests itself through its visible form, symbolizes this very balance

between permanence and change, between the city and its citizens, between the stones and the people.

Indeed, there's nothing more coarse, pointless, and misleading than the false contrast between conservationists and innovators: a common refrain employed in the public discourse of our times, afflicted as it is by superficiality and ignorance. These days, self-styled "innovation leaders" seem to pop up at every turn to trigger witch hunts against the "conservationist mullahs," depicting them as opposing any sort of change, who dream of an impossible world where landscapes, cities, and monuments can go into hibernation, thus condemning them to a perpetual slumber. However, our cities' historical memory doesn't seek inertia, it seeks movement. It doesn't wish to be embalmed, but rather exalts life. The kind of life and movement that nevertheless respects the city's DNA, which favors a harmonious sort of growth, and not violent destruction; that gently grafts new kinds of architectures onto it, or restores its ancient ones, and does not brutally violate its shape and soul. Yet those who launch attacks against "conservationist mullahs" are the same people who promote indiscriminate intrusions, becoming complicit in the ruthless devastation of our cities.

For our cities to engage with what the Greek philosophers discussed as the "paradox of growth," it is necessary to reflect on their DNA, but also on an adequate poetics of reutilization. Would the temple of Athena in Syracuse (built in the 5th century BCE) have survived if it hadn't been transformed into a church, then into a mosque, and finally back into a church until its present incarnation as a cathedral? And when we step inside the Pantheon in Rome and stand beneath that 1900-year-old cupola, do we not also accept the presence of the Christian altars, Melozzo da Forlí's *Annunciation*

and Raphael's tomb? Do we not owe Pope Boniface IV a debt of gratitude for having converted it into a Christian church and consecrating it in 609 CE? Would Trajan's Column have remained intact for nineteen centuries if it hadn't been used as a bell tower for the San Nicola de Columna church in the medieval era? In these cases, among many others, the process of reutilization incurred losses, as well as modifications, although it nevertheless guaranteed the survival of the whole; and what is true on the micro-scale of monuments is also true for the macro-scale of the city. Italian cities are a wonderful palimpsest, where sometimes even the city's walls clearly show the succession of historical ages (for instance in Cortona in Tuscany, where one can see the progression from the Etruscan period to the Roman one, the medieval one, and finally the modern era). The fabric of the city survives through mutations, replacing some buildings while preserving others, either retaining their original role or giving them a new one.

Over the past few years, it has become fashionable to talk about "creative destruction": Max Page did so in his *The Creative Destruction of Manhattan* (2001), while nevertheless echoing Rem Koolhaas's formula in his *Delirious New York* (1978, new ed. 2014), where he wrote: "In Manhattan's Culture of Congestion, destruction is another word for preservation." Even David Harvey mentions creative destruction in his recent book, *Rebel Cities: From the Right to the City to the Urban Revolution* (2012), where he employs this category to describe a group of radical urban restructuring projects that were achieved at the expense of low-income workers. "Violence is required to achieve the new urban world on the wreckage of the old," Harvey tells us, using the example of Napoleon III's destruction of Parisian slums. Horst Bredekamp's book about St. Peter's in Rome was also subtitled "The Principle of Pro-

ductive Destruction." Even in the context of urban sociology and the history of architecture, this formula has been adapted wholesale from the language of finance, which has gained currency thanks to the theories of economic innovation developed by Joseph Schumpeter in *Theorie der wirtschaftlichen Entwicklung* (1912), which in its turn was rooted in Marx's ideas. Then again, Bredekamp writes: "Schumpeter's belief that historical events and their narration do not happen in an 'eternal lull,' but rather in the midst of a 'gale of creative destruction' is perhaps most convincingly proved when looking at the history of how St. Peter's was built."

The destruction of the Old St. Peter's Basilica built by Constantine I and its replacement with the new symbol of papal primacy has nothing to do with the Japanese paradigm of the Ise shrines; if anything, it bears a closer resemblance to Hume's English church, which is rebuilt in keeping with "modern architecture." If destruction and creation become one and the same here, as is obvious, we must ask ourselves a simple question. What would we say if the reigning pope wished to demolish St. Peter's today and build a more modest and less pompous one in its place, in accordance with his ecclesiastical ethics, or in keeping with modern architecture? In the 1500s, many deplored the destruction of the early Christian basilica, but the rise of a new culture of conservation of our cultural heritage means that demolishing St. Peter's Basilica as it stands today would be practically impossible. Nor would we consent to Trajan's Column being re-purposed as a bell tower; in fact, over the past few centuries, a new sensibility has arisen which does not tolerate these sorts of hybridizations.

The culture of conservation is an inescapable historical fact, which the Italian judicial system codified into a number of laws, and finally enshrined in Article 9 of the Constitution,

thereby turning it into one of the state's guiding principles. Thus, preserving rather than destroying is also a legal issue in Italy. There's an entirely different situation with Manhattan's grid plan, where the destruction of a building does not preclude the preservation of its spirit from being reincarnated in a new structure (Koolhaas). Similarly, the destruction of the old, wooden Doric temples in ancient Greece was necessary in order to allow its soul to be transplanted into an edifice of stones. In the 2nd century CE, Pausanias noted that there was still an oak column to be seen in the Temple of Hera in Olympia amid the ones made of stone, which by that time were already several centuries old.

The principle of creative destruction can never be applied indiscriminately to stimulate the growth of a city. In fact, the mere act of using a metaphor drawn from the language of economics to define cultural or urban developments is both risky and ambiguous. As far as Schumpeter was concerned: "This process of Creative Destruction is the essential fact about capitalism … a process of industrial 'mutation'—if I may use that biological term—that incessantly revolutionizes the economic structure from *within*, incessantly destroying the old one, incessantly creating a new one."

Is this really the model we want to adopt for our cities, monuments, and culture? The emphasis on production inherent in Schumpeter's formula prompts an inevitable question: If we destroy something, what are we going to build in its place? Once we're done destroying a city's historic center, or a monument, or a cultural institution, will the new structure that replaces them really benefit the community?

Schumpeter's metaphor is also highly ambiguous: it assumes that the old and the new must size each other up from a purely economic point of view. Accordingly, let us sup-

pose that knocking down Ferrara's walls to replace them with a cordon of skyscrapers could be considered an act of creative destruction. This would be the same rationale employed when it comes to abolishing state subsidies to schools, universities, research institutes, and cultural initiatives in order to finance other areas of public expenditure (war planes, and other great "public works" such as the Strait of Messina bridge, which would link Sicily with the southern tip of mainland Italy, and so forth) in the way Italian governments have repeatedly done. The point here is that if we really wanted to have a serious discussion about creative destruction from a sociocultural point of view, it must actually *produce* something, not just in terms of profit, but of actual values, or in other words, to employ another, possibly better suited economic metaphor, creative destruction must produce "civic capital." Meaning a sense of community, the power of beauty and memory, enabling citizens to identify with a forma urbis in which they can recognize themselves. If any of these elements are missing, or worse, repeatedly trampled on, no amount of destruction will ever really be creative. A single, macroscopic example will suffice: the desolate suburbs which now ring our cities and betray their spirit and DNA, have destroyed the countryside and entire landscapes, but they failed to produce any civic capital, in fact they merely generated profits for real estate speculators and construction companies.

If we wish to speak of high-quality architecture, a new building could certainly bring some kind of civic capital to a city and could even be desirable, although it should not be taken for granted that it will. Mario Botta, one of the great architects of our times, gave us a fantastic example of how this can be achieved with his design for the Museum of Modern and Contemporary Art of Trento and Rovereto in northern

Italy, which was perfectly inserted into the historic urban fabric, not only increasing the numbers of tourists and visitors, but also injecting new lifeblood into Rovereto's culture, its ambition for the future, and its civic identity. Yet the very same architect also designed a two hundred-foot-tall residential tower in Sarzana, near Pisa, which did in fact produce some civic capital, yet of a wholly different nature: it sparked protests by a local citizens association and the comment from anthropologist Franco La Cecla that "cubic meters by famous architects don't make a city."

The purely economic way in which the formula of creative destruction is used becomes all too clear when the destruction is wreaked by natural causes, and yet the creators of new cubes cheerfully rush to the scene of the disaster to deploy their creativity. This is exactly what happened to L'Aquila in central Italy in the wake of the 2009 earthquake when the picturesque fortress city was reduced to ruins; or what happened in the Emilia-Romagna region where, after the government had allowed belfries and towers to collapse out of negligence soon after another earthquake, a restoration conference held in Ferrara in 2013 launched a rebuilding initiative under the slogan "Where it was, but not how it was." Some of the proposed models included a tower festooned with enormous red lips, or a tower built entirely out of wheels of Parmesan cheese, one can only assume out of respect for local culture. In cases such as these, Schumpeter's formula is completely out of place. In fact, it would really be more appropriate to describe these instance as examples of *destructive* destruction, where architects, city and state authorities, and even conservationist organizations actually compound the devastation caused by the earthquake and finish the job that it started.

Instead, when St. Mark's Campanile collapsed on July 14,

1902, it was decided that an exact replica of the bell tower would be built in exactly the same place. The same went for the Santa Trinita Bridge in Florence and the Palazzo dell'Archiginnasio of Bologna after they were destroyed by aerial bombardments during World War Two. It's difficult to imagine how those cities would look today if this hadn't happened. In Venice, the Campanile is affectionately referred to as *el paròn de casa* by the locals—the man of the house—because its presence and imposing height (almost three hundred feet) towers over the square and the city. Venice might seem to some like a good place where one could experiment with real estate projects and acts of destruction that are more or less creative, and crush the present in the name of the futuristic. Indeed, if it continues to lose its inhabitants in the way that it has, it may well become such a laboratory, until it finally transforms into a city without a people.

On the other hand, Venice could maintain its unrivaled forma urbis if it learns how to interpret the paradox of conservation through the prism of its own DNA; if it will learn to employ a poetics of reutilization that doesn't limit itself to mass tourism. If it doesn't stick to the unsuccessful model of an embalmed city, but instead slowly ponders each and every change, ensures that all new structures are both delicate and well thought out, given how even the slightest move might alter its precious fabric. Venice will be able to respect itself only if, in the words of Plutarch, it realizes it can still be "like a living thing ... a united and continuous whole [which] does not cease to be itself as it changes in growing older, nor does it become one thing after another with the lapse of time." If it will remain "at one with its former self in feeling and identity and must take all blame or credit for what it does or has done in its public character" so that "the community, which is held

together by operational links, retains its unity." And let us add a final condition: Venice must know how to creatively construct its own destiny, tailoring each change it makes according to the best possible future for its citizens, and not what the tourists or real estate agencies want.

CHAPTER IX

Replicating Venice

Locked in its lagoon, Venice has nevertheless managed to inspire the world. The sudden collapse of St. Mark's Campanile in 1902 and the swift move toward its reconstruction "as it was, where it was," completed in 1912, triggered the construction of a wave of replicas—of varying dimensions—during the early 1900s, especially in the United States. Thus, one can see Venetian bell towers in the train stations of Seattle (1904, 242 feet tall) and Toronto (1916, 140 feet), the Daniels & Fisher Tower in Denver, Colorado (1910, 324 feet), on Berkeley's campus (1914, 308 feet), Brisbane's City Hall in Australia (1917, 298 feet), and Port Elizabeth's City Hall in South Africa (1920, 170 feet). The imitations of St. Mark's Campanile in New York, which are veritable skyscrapers in their own right, are still in use and are far taller than the original: the Metropolitan Life Insurance Company Tower on Madison Avenue (1909) is 698 feet tall, while the Bankers Trust Company Building on Wall Street (1910, 505 feet)—now known as 14 Wall Street—is topped off by a temple inspired by the Mausoleum at Halicarnassus. The death and resurrection of a famous piece of historic architecture directly led to these and other imitations which drew from its form in order to add a touch of nobility to their universities, train stations, department stores and city halls, but above all, their skyscrapers.

Even the city of Venice, California was founded during those years—in 1905 to be exact, by the tobacco magnate Abbot Kinney—and although it doesn't have a campanile, it does have a Doge's Palace, which truth be told is rather modest. There are still a few canals and once upon a time it even had gondolas and gondoliers. It was an immensely successful real estate venture, given that Kinney and his business partner owned almost all of the land on which the new city was built. Its original name, "Venice of America," was an even more explicit reference to the Italian Venice. The idea was to build a compromise between a city and an amusement park, and to provide a little color for visiting tourists (the color, of course, was all fake) in order to lure them to the Pacific coast, which, needless to say, didn't resemble Venice in the slightest. Venice, California was therefore a direct predecessor of Disneyland (which opened in 1955, just fifty miles down the road); Venice's remaining canals were listed on the U.S. National Register of Historic Places in 1982.

There are twenty-seven other Venices in the United States, and twenty-two in Brazil; Fort Lauderdale in Florida is also known as the "Venice of America," just as Aveiro is called the "Venice of Portugal," while cities like Amsterdam, Birmingham, Bruges, Copenhagen, Giethoorn, Hamburg, Saint Petersburg, Stockholm, and Wrocław have each been called the "Venice of the North." The various cities wearing the badge of "Venice of the East" like Bangkok, Hanoi, and Udaipur are almost too many to count: Japan alone has eight which have been granted that title. Not to mention the neighborhoods that have been called "Venice" around the world, from Livorno to Le Havre, from Strasbourg to London (there's an area in Maida Vale called "Little Venice"); or in Venezuela, whose name (again, "Little Venice") was inspired by the sight

of indigenous people's houses on stilts in Lake Maracaibo. Very rarely do these cities or neighborhoods feature relatively successful imitations of buildings found in the original Venice; what generally ties them together is the fact that most have dense networks of canals that allow for a way of life that the real Venice pioneered and is still the prime example of.

In order to evoke Venice, in the context of a culture that is easily pleased, one merely has to bring up a canal, or a building whose image is reflected in its waters, a doorway or two giving directly onto the water, or even just a few boats moving alongside some houses. The opposite, however, does not happen: as far as I'm aware, nobody has ever called Venice the "Stockholm of the Adriatic." The image of the one and only Venice is far too vivid for that, in fact it overwhelms other associations and is a touchstone. Multiplied by its myriad evocations, is the idea of Venice reinforced by this process, or does it instead splinter? Is the widespread fortune its name has enjoyed (which some argue is the most copied name in the world, even beating its closest competitors, Paris and Rome) linked to its picturesque appearance, or is it instead caused by the subtle interest it inspires due to its unusual take on urban living? Does it implicitly invite a desire to imitate its beauty, or evoke the tendency to consider it exotic and unlikely (and therefore "entertaining")?

The idea of Venice as an amusement park wasn't merely limited to early 20th century California. The Venetian Resort Hotel in Las Vegas, Nevada, features four thousand rooms and its complex hosts an adjacent casino in the middle of a miniature Venice built from scratch. It features replicas of St. Mark's Campanile and the Rialto Bridge in half scale, as well as canals with gondolas coursing through them, along with scaled replicas of the Doge's Palace and the Piazza and Piazzetta of San Marco. The Venetian has offered its guests all this and

more ever since Sophia Loren celebrated its opening aboard a motorized gondola in 1999. Of course, the ubiquitous skyscraper made its mark here too in the shape of the Venezia Tower, whose thirty-six-story, 475-foot height added 1,013 suites to the complex, as well as a wedding chapel. Is that too kitschy? Yet when two prestigious museums—the Hermitage and the Guggenheim—wanted to open a kind of joint venture in Las Vegas in 2001—which was formally called the Guggenheim Hermitage Museum, but was informally known as "The Jewel Box"—they chose to situate it right inside The Venetian, showcasing works by artists ranging from Titian to Jackson Pollock, a disastrous move which forced the museum to shut its doors only a few years later in 2008.

In his 2007 book *Welcome to Venice*, journalist Guido Moltedo provides us with an inventory of this Vegas Venice, which is no longer unique, but as the book's subtitle says, has been "imitated, copied and dreamed a hundred times." To name just a few examples: in 2007, The Venetian Las Vegas spawned a kind of clone in Macao in 2007, which was just as gargantuan as its predecessor: the Venetian Macao Resort, replete with its own skyscrapers, gondolas, St. Mark's Campanile and Rialto Bridge is the biggest casino in the world. In Kundu, Turkey, not far from Antalya, the Venezia Palace Deluxe Resort Hotel features approximate copies of the Horses of Saint Mark, which overlook the usual panoply of copies centered around the Campanile. This is an interesting example of reclamation, considering that the original Horses of Saint Mark were brought to Venice after the sack of Constantinople in 1204 during the Fourth Crusade. In fact, Istanbul is the location of Viaport Venezia (which is located in the Gaziosmanpaşa district): a pool of water surrounded by five skyscrapers, with 2,500 apartments between them (the tallest tower is 495 feet), which

also features a shopping mall, various canals, Venetian-style bridges, and a few gondolas. The slogan which appears on Viaport's website is: "You no longer have to travel to Venice to experience Venice." There's even a Venice in Dubai, in the shadow of Burj Khalifa, currently the tallest skyscraper in the world (2,716 feet), although this particular one features only a few canals and boats and doesn't sport replicas of St. Mark's Campanile and the Rialto Bridge. In Qatar, there's another fake Venice dominated by grimly conspicuous skyscrapers.

The common thread in these examples is the impoverished transposition of Venice, whereby it is reduced to a picturesque accessory, a small-scale replica constructed with cheap building materials, but is nonetheless presented as the epitome of luxury. It seems that in order to experience Venice, one need only cross a little bridge over a fake canal while eyeing a useless gondola moored nearby. These fake Venices decorate five-star hotels or prestigious residential neighborhoods, just like in the Turkish Viaport Venezia, where a "perfect life you could not find even in Venice awaits you." The skyscrapers that constitute this real estate venture, arranged around a pool of water, reevoke (is this mere coincidence?) the ring of skyscrapers that might be built around the real Venice in 2060, as envisioned by the Aqualta project. Even when it comes to these fake Venices, one or more skyscrapers tower over the small-scale reproductions of St. Mark's Campanile, looking down on it as a giant would a dwarf.

Yet nothing can compare to what is currently happening in China. Macao, with its legacy of Portuguese colonial rule, is almost an extension of the West (just like Hong Kong), and this might explain why it cloned Las Vegas's fake Venice. However, all over the country, the massive population movements, coupled with the rapid industrialization of the

countryside and the construction of megalopolises have led
to the radical destruction of historic towns and the symmetri-
cal creation of French, Spanish, Dutch, and English residential
neighborhoods (as is the case in Huizhou). In order to pro-
vide a little color or flavor, there are even churches, which are
actually used as theaters: whereas churches in European cities
have been increasingly reutilized once the sacred edifice is no
longer used as a place of worship, this becomes the primary
function of churches in China, which were never actually used
as churches to begin with, thus depriving their architectural
form of any depth or meaning.

The New South China Mall in Dongguan, fifty miles
northwest of Hong Kong, is the largest shopping mall in the
world. The mall has seven zones modeled on just as many
geographical areas, including Rome, Venice (with a St. Mark's
Campanile and various canals), Paris, Amsterdam, Egypt,
the Caribbean, and California. The mall, which opened in
2005, has suffered from a severe lack of occupants and over
90 percent of its available stores have been vacant. As Bianca
Bosker noted in her recent book, *Original Copies: Architec-
tural Mimicry in Contemporary China*, a vast district which
closely mimicked Venice was built not far from Hangzhou and
is called Venice Water Town:

> As in the original Venice, the town houses are
> painted in warm shades of orange, red and
> white. The windows feature balustrades and
> ogee arches and are set into loggias framed in
> stone. The structures blend Gothic, Veneto-Byz-
> antine and Oriental motifs and overlook a net-
> work of canals on which "gondoliers" navigate
> gondolas under stone bridges. The property's

crown jewel is a replica of Saint Mark's Square
and the Doge's Palace in the town square, com-
plete with Saint Mark's Campanile; a pair of col-
umns topped with gilded statues of the lion of
Saint Mark and Saint Teodoro of Amasea, the
patrons of Venice; and ornate patterned tiles on
the façade of the "Doge Palace."

According to Bosker, these architectural ghosts are sup-
planting the authentic historic city centers of Chinese cities,
which were demolished because they were a standing reminder
of poverty, whereas Alpine villages, Italian squares and English
churches seemingly evoke the prosperous societies with which
China's *nouveaux riches* wish to identify. Could this be explained
by the fact that, as Umberto Eco noted, "baroque rhetoric,
eclectic frenzy, and compulsive imitation prevail where wealth
has no history." Bosker has suggested another explanation, and
in her book she retraces the long Chinese tradition of "thematic
appropriation" of foreign architectural styles, which began "in
the late third century BCE," when after having conquered the
last six independent kingdoms, the First Emperor "replicated
each of the [dethroned rulers'] local palaces (probably in min-
iature, perhaps two-thirds scale) along the banks of the Wei
River outside his own capital city of Xianyang." It is more likely,
however, that this is the result of the passive mimesis of those
who chase wealth, in Eco's words, which has combined with a
civilization that is used to absorbing others, all of which has
taken place under the aegis of runaway capitalism, even though
it is led by a nominally Communist Party.

This is architecture as ersatz, a deception, a simulacrum.
Ersatz (literally meaning substitute or replacement) is a Ger-

man word which worked its way into English during the two world wars, when it was used to describe a substitute good that was usually of inferior quality to the original good that it replaced (as was the case with *Ersatzkaffee*, which was called *Caffè d'orzo* in Italy and was made from barley rather than coffee beans, and so forth.) While the St. Mark's bell towers which were replicated in the United States and elsewhere in the early 20th century were respectful homages to the one in St. Mark's Square, the ersatz architecture of these fake Venices supplant authenticity, memory, and history with their impromptu set designs, and in order to do so employ drastic selective criteria. For instance, none of these fake Venices include a replica of St. Mark's Basilica (which is simply too complex to reproduce), while it never even crossed anyone's mind to feature replicas of the nearby Giudecca, or Campo San Polo, or the Basilica di Santa Maria Gloriosa dei Frari, or the Scuola Grande di San Rocco. Thus, in order to clone Venice, one must first mutilate it, getting rid of 99 percent of it to reduce it to a caricature of itself, stripping all the meat until one is left with a bare bone. But the very moment that it is flaunted as a model, it automatically rips all the charm, richness, and diversity out of its urban fabric. Nevertheless, there is no shortage of those who think that Venice (the real one) can draw two-fold advantages from its pale imitations: it can redirect a great many of the tourists who are afflicting it to these imitations, and demand royalties from those who wish to copy it. Yet what if the exact opposite were actually happening? What if the fake Venices scattered around the world are corrupting the real Venice's image of itself? What if they became its hidden model? What if a Venice without Venetians tried to find its own identity in places like Las Vegas, Dubai, or Chongqing?

CHAPTER X

History's Supermarket

The creation and management of architectural counterfeits is a consciously negotiated process just like any other trade deal: there are those who invest and build counterfeits, and those who pay to use them. Thus, these replicas have to present themselves as faithful copies, precisely because they are not; the unwritten agreement between the buyer and seller is built on a fiction that the game is free, whereas it has a very specific price. This price isn't merely monetary, it is both social and cultural: history becomes a tradable good, while its cloning is merely the packaging it is wrapped up in so as to sell it on the market. What Umberto Eco once wrote about the United States some thirty years ago is now true in much of the rest of the world: "If a reconstruction is to be credible, it must be absolutely iconic, a perfect likeness, a 'real' copy of the reality being represented. Whenever imagination aims at recreating 'the real thing,' it must craft an absolute fake."

Thus, the residential neighborhoods and shopping malls that mimic the encapsulated form of a historic city closely resemble open-air or living history museums, where as Eco wrote, in order "for historical information to be absorbed, it has to assume the aspect of a reincarnation."

Colonial Williamsburg in Virginia, the most famous living history museum in the United States, restored and

re-created the historic center of that city to preserve its appearance. Thus, in 1926 a cutoff date was chosen—1770—and every building that had been built since, including those built in the early 20th century, were either destroyed or altered: 731 structures were torn town, 413 were rebuilt in their original location but adhering to forms established before 1770, while only 81 were preserved and restored. In this extreme case of purism, what was destroyed greatly outweighed what was actually preserved: the keyword used to justify this course of action was the singular concept of "authentic reproduction," an oxymoron that confesses to the fact that this is all make-believe, and yet simultaneously tempers it with a seal of authenticity. Conservation efforts thus run aground and shatter on a mix of what is truly ancient, and what merely *looks* truly ancient. As the architecture critic Ada Louise Huxtable pointed out, this tangle of narratives has:

> taught many of us to prefer—and believe in—a sanitized and selective version of the past, to deny the diversity and eloquence of change and continuity, to ignore the actual deposits of history and humanity that make our cities vehicles of a special kind of art and experience, gritty accumulations of the best and worst we have produced. This record has the wonder and distinction of being the real thing.

The key to understanding the construction of this artificial past lies in the synchronicity between Colonial Williamsburg and Rockefeller Center in New York City. John D. Rockefeller, Jr., played an active role in both projects. In the words of

Rem Koolhaas: "One enterprise is the fabrication of a past, the other—in a collapsing economy—the restoration of a future."

Living history museums have become widespread throughout the world, fostering very peculiar conservationist tactics, such as demolishing entire villages and rebuilding them from scratch, while nevertheless taking apart some unique buildings in order to reassemble them elsewhere, artificially grafting them onto houses and churches belonging to other villages. The oldest instance of this practice, which in fact has become a constantly replicated model, is the collection of ancient buildings that was assembled by King Oscar II of Sweden and Norway in 1881 and 1882 and has since been extensively added to over time. Relocated from the royal estate, these buildings were then moved to the Norsk Folkemuseum in Bygdøy, a peninsula on the western side of Oslo—where, starting in 1915, an entirely new neighborhood called the Old City was built, in order to "provide a safe-haven for urban housing in need of help." After Norway's independence in 1905, the importance of this open-air museum as a symbol of a new national consciousness grew even further. Today it contains more than 150 buildings drawn from across the entire country, which were taken apart and then reassembled employing so-called restoration tactics that all too often amounted to total renovations.

Meanwhile, the Skansen open-air museum was established in 1891 on the island of Djurgården in Stockholm; the museum was designed with the idea that the wooden structures could easily be removed and transplanted elsewhere. This later served as a model for similar initiatives in Russia, where *Skansen* in fact became the term used to describe these types of museums. Beginning in 1927, a few historic buildings from other areas were transported to Kolomenskoye, close to Moscow, but the most famous of these open-air museums was

situated on Kizhi Island, in Karelia, and was founded in 1961. Some even more recent museums of the sort can be found in Germany, including the Black Forest Open Air Museum (1963), located between Hausach and Gutach, and the Frei-lichtmuseum (1988) in Neuhausen ob Eck, both of which host a few dozen structures explicated by an educational appara-tus and presented as a coherent whole. Just as was the case with Bygdøy, the task of imparting knowledge of the past is entrusted to a village which never actually existed in the past—and which is in fact composed of structures extirpated from their historical context, tearing that fabric asunder forever. The new context presents itself as more real than real, owing to its museum-like character, its educational efforts, the employees dressed in ancient costumes who wander around the grounds during opening hours pretending to be blacksmiths, farmers, and sheep-herders who belong to a different era. This is how it's done at the Plimoth Plantation living history museum in Plymouth, Massachusetts, which commemorates the landing of the Mayflower and the Pilgrim fathers, and where the actors are instructed to speak among themselves (and with tourists) in 17th century English.

A precarious balancing act distinguishes open-air muse-ums, like the one in Bygdøy, which house partly authentic structures, even though they were ripped from their historical context—and the reconstructed villages built atop minimal or nonexistent archaeological remains like in Plymouth. In either case, the old ways of living are made both popular and acces-sible through forgery. Nevertheless, despite appearances, the most radical gesture is not the exercise of rebuilding ancient settlements (an example in Europe is the Roman city that was rebuilt in the Archaeological Park in Xanten, Germany), but rather the Norwegian-style dislocation of historical buildings

which are then reassembled within special enclosures. Just like in a refugee camp, the buildings *worthy of being preserved* are not allowed to remain where they stand, but are instead "benevolently" saved and taken elsewhere. Only the present has a valid right to citizenship, while history is relegated to the status of an interval, a relic, a retirement home.

The obvious precursors of living history and open air museums and theme parks were the world's fairs, which, starting with the enormous success enjoyed by the one in London in 1851, were prime showcase opportunities to compare new inventions, industrial and agricultural products, and local cultures. Under the auspices of an incipient culture of consumption and entertainment, it was considered desirable to exhibit something of one's history and traditions alongside the products of each country. The Norsk Folkemuseum made its first appearance at the Exposition Universelle in Paris in 1889; Budapest's Millennium Exhibition in 1896 featured an entire rural village—complete with inhabitants—assembled especially for the occasion. During the St. Louis World's Fair in 1904, six hundred veteran soldiers reenacted scenes from the Second Boer War, which had only ended a couple of years earlier. These were ephemeral replicas, almost like theatrical representations repeated on a daily basis, but only during the few months that the fair was held; they exercised a claim to authenticity as well—featuring real Hungarian peasants, real English and Boer veterans—which would be impossible in a permanent museum. What binds these temporary replicas exhibited at the world's fairs to the permanent ones found in living history museums is that in both cases one must pay a fee to access their history and geography; on the other hand, what sets them apart is that a living history museum and a theme park by its very nature implies a higher degree of adulteration.

This manipulation of history reaches its climax in the pro-liferation of theme parks in East Asia. If American open-air museums and living history villages were meant to remedy the paucity of historical places that lend themselves to both memory and tourism, the Chinese equivalents have replaced their own history with those belonging to others. As Koolhaas wrote: "We could ... say that Asia as such is in the process of disappearing, that Asia has become a kind of immense theme park. Asians themselves have become tourists in Asia." On the other hand, according to author Ian Buruma, the Special Economic Zones, like the one in Shenzhen—which were set up by Deng Xiao Ping in 1979 under the popular catchphrase "To get rich is glorious"—were built as capitalist theme parks whose architecture and landscape followed economic and social needs only to a certain degree. First, these enclaves had to be made to look like great, wealthy, businesslike cities, even if half the skyscrapers had to remain empty of people, and superhighways relatively free of cars.

In a dramatic reversal of values and practices, theme parks like these do not reproduce the past, but instead shape the direction of the future. Instead of replicating the plausible appearance of an urban center which was situated in the same area in 1770, as was the case with Williamsburg, Shenzhen adopted the American-style city's forma urbis wholesale. It didn't copy the specific buildings of a specific city, but rather built a Pleasantville or Seaside-style settlement and presented it as authentic; a scenario suited to influencing mentality and behavior and gearing them to market practices. Deng's enclaves were the incubators of China's current megalopo-lises, just like Frederic Thompson's Luna Park (1903), which was built on models first developed during the Chicago World's Fair of 1893 and created a skyline of 1,221 towers,

minarets, and cupolas on Coney Island that presaged Manhattan's skyscrapers. This was, according to Koolhaas, "the first City of Towers: functionless, except to overstimulate the imagination."

Being projections of what the future might look like, theme parks can also express nostalgia for a certain past. Just outside Chongqing, an urban jungle of skyscrapers populated by 32 million people, a copy of San Gimignano is currently under construction and is to include 625 acres of Tuscan landscape, destined to become a gigantic shopping mall. Just like a homeopathic remedy, the tranquil lifestyle of a fake Europe is being used to balance out the congestion of a megalopolis built along American lines—provided of course that the ritual there doesn't limit itself to escapism but instead fuels compulsive shopping. As art historian Tomaso Montanari put it, these "outlets of history, and malls born of a culture where customers have replaced inhabitants," are not an exotic aberration, given that the architects responsible for the projects are from Pisa; quite the contrary, they are the mirror image of slogans that used to be popular in Italy twenty years ago, which depicted historical cities as "natural shopping centers." (In 2010, the province of Tuscany published a report on the operation of natural shopping centers, while the region of Campania passed a specific law to promote them in 2009.)

Even Disneyland is a kind of open-air museum. Founded in 1955 in California, it has been duplicated several times, first on a much bigger scale, near Orlando, Florida (1971), then in Tokyo (1983), Paris (1992), Hong Kong (2005), and finally Shanghai (currently under construction). "An immense and displaced metaphor of the system of representation and values unique to American society," in the words of French philosopher and art critic Louis Marin, Disneyland blends

the known with the unknown, the real with the imaginary, cartoon characters and people made of flesh and bone, city streets and shopping malls, Paris and Main Street, USA. As the element of fiction here is fully acknowledged, it requires complete passivity from tourists in order for them to play their part, adhering to a script that never changes: park the car (and not cheaply), wander around the theme park while choosing which attraction to visit, allowing yourself to be carried away by that attraction, while of course continuing to shop. Disneyland is far more honest when it depicts an entirely fictional area, like Mickey Mouse's house, but far less so when it offers one the experience of being on a Paris street, as though it were just a tiny corner of that theme park. The ephemeral experience of those who visit theme parks and those who go about their daily lives in a fake Venice share a common platform: the idea that history, architecture, the forma urbis are just like any other good that can be put into circulation (and bought and sold) through duplication techniques.

These sociocultural practices are contiguous to other simulations, like the irruption of virtual reality into the world of museums and research strategies. Throughout his book, *Do Museums Still Need Objects?*, historian Steven Conn asks that very question, and he argues that as our "faith in the power of objects to convey knowledge, meaning, and understanding" diminishes, so do the number of objects exhibited in galleries and museums, while the information equipment that frames them increases exponentially. The new experience of museum-going relies on technology to talk about history, and favors virtual representations of reality, conferring a degree of truth and intensity on images flashing across a screen or a smartphone that do not make any claims to being the real thing, but instead wish to be more than that. It allows for images

to be manipulated—for example by allowing one to zoom in on a particular detail—or allows visitors to interact with and observe the images (even after their actual visit to the museum is concluded) as well as the archiving of visitors' impressions, as exchanged on Facebook and other social media. The artwork isn't swallowed up by this enriched virtual reality, but is instead increasingly understood as the mere trigger of a sensory and intellectual process that mostly takes place somewhere else.

For instance, if we talk about Velázquez's *Las Meninas*, let's say that 20% of the experience lies in standing in front of the canvas at the Prado in Madrid, yet 80 percent takes place on a smartphone or iPad, inside a maze of interactive features that enable new forms of appropriations. As Conn writes, "in a media-saturated, hyper-consumer society … objects can be seen as stodgy and inert," and in order to compete with other forms of entertainment, museums have started to rethink themselves through virtual reality. Similarly, cyber-archaeology—a disciplinary practice that doesn't emphasize the historical interpretation of the data derived from the dig, but instead on processing that data in order to produce a virtual simulation of archaeological sites—is all the rage today. These days, the development of technologies for manipulating data tend to be the real aim of one's search; and instead of recovering pottery fragments from a dig site, archaeologists now tend to handle and recombine kilobytes in their vast databases. Illusion has supplanted reflection, while copying has ousted historical analysis. The irreducible diversity of the past has been diluted into a gratuitous kind of DIY rooted in the present.

Let us therefore pose the following question to ourselves: Can a historic city, even one like Venice, now be considered

as "stodgy and inert" as the objects that Conn says are exhibited in the museums of a "saturated, hyper-consumer society?" And if so, will we have to resort to the unencumbered cheerfulness of one of its copies to overcome the boredom of the original Venice?

CHAPTER XI

The Truth of the Simulacrum

Simulation is the keyword that runs throughout this extraordinary cultural transformation. It includes several levels of virtual reality and various methods of reproducing monuments or historic cities: you can replicate Venice "in the flesh" inside a Las Vegas casino or a neighborhood in Istanbul, but you can also situate it inside a virtual city which anyone can explore via their avatars from the solitude of their own home.

We cannot reduce this shift to an ephemeral fashion trend, or consider it a tribute to our dominant technologies and market mechanisms. Another factor is at least as important: the need to explore notions of diversity, which has been prompted by the global widening of our horizons. As University of California at Berkeley architectural professor Nezar AlSayyad argued, the need to "find authenticity and truth in times and places away from his/her own everyday life" has been answered in part by mass tourism, whose unexpected metamorphosis conferred the obsolete practices developed during the era of the Grand Tour to countless multitudes of *petits touristes*. That slow kind of traveling, once the exclusive preserve of learned elites—and which was thus inspired and nurtured by a great deal of reading, or accompanying tutors and guides and the production of countless diaries and watercolors—has been shattered by the impalpable rhythm of mass

tourism. Nevertheless, the direct experience of urban space, accommodation, and ways of living that are not one's own, has remained an essential component of travel, even though the current practice of hit-and-run visits often elicits meager results (75 percent of those who visit Venice stay there only for a day). Souvenir snapshots—where quantity trumps quality—are a testament to the tourists' ritualistic presence, and not their cultural curiosity. Photographs do not preserve a memory; instead they have replaced our remembrance and our ability to see.

The fake Venices of Las Vegas, Dubai, and Chongqing are even more paltry responses to that need for diversity and otherness, which can find a second-rate outlet in both forged and virtual realities. Yet the pervasive manner in which virtual reality has gained the upper hand and blurred the line between the fake and the authentic while simultaneously subverting its terms amounts to this: virtual reality can be better than normal reality not only because it is more immediately accessible, but because it elicits more standardized (and therefore more marketable) emotions. Instead of introducing something real, virtual reality can simply take its place; physical reproductions found in theme parks—or pseudo-historical neighborhoods, those open-air museums that re-create a fake German or Norwegian village using authentic building materials—can do this in an even greater capacity.

In his *Repairing the American Metropolis: Common Place Revisited*, urban planning and architecture professor Douglas Kelbaugh quotes a college graduate just back from her first trip to Europe:

> I didn't like Europe as much as I liked Disney
> World. At Disney World all the countries are

much closer together, and they show you just
the best of each country. Europe is boring. Peo-
ple talk strange languages and things are dirty.
Sometimes you don't see anything interesting
in Europe for days, but at Disney World some-
thing different happens all the time and people
are happy. It's much more fun. It's well designed.

It's hard to believe that someone actually mouthed such
embarrassing words, but the logic they employ is certainly
authentic: what is different is boring, and what is identical (to
ourselves) is reassuring, and thus it makes us happy. It would
be useless to laugh this off, since the Disneyfication of our
cities proceeds unabated day by day, and with it the tacit strip-
ping of their variety, diversity, and identity, a process whereby
history is reduced to a mere brand. Even in Venice. In fact,
especially in Venice. According to several observers—and I'm
going to quote only from an article called "The Ugly Side of
Venice," which appeared on the Gourmantic website—the real
Venice is becoming less welcoming than its knockoffs:

Ugly monstrosities in the form of massive ad-
vertisements covered the iconic buildings ...
Ponte dei Sospiri was barely visible, dwarfed by
fake skies and make belief [sic] clouds. Further
along, Piazza San Marco was under the effects
of *Acqua Alta*. But this inconvenient yet natural
phenomenon paled in comparison to the giant
Trussardi advertisement towering above the
square ... Granted, many of Venice's buildings
are in a state of disrepair and require sizable
funding for restoration. But hiding the beauty

of the city with ugliness should come with a travel warning. Don't come here ... *La Serenissima* is no longer serene. The city itself is no longer a pleasure to be in ... I didn't raise an eyebrow at the multilingual signs on rubbish bins forbidding tourists from littering, loitering, eating and drinking in Piazza San Marco.

Comparing Venice to Disneyland has now become commonplace; without citing too many examples, simply two will suffice. In 1981, the Italian journal *Urbanistica* published an article which argued, among other things, that "the transformation of Venice into Disneyland could very well signal the transition to a more creative and cheerful way of life." The author in question was a professor of urban planning, had edited *Urbanistica* for seven years, and was subsequently a member of Italy's Higher Council for Cultural Heritage and Landscape. The second example is culled from an advertisement posted on the Internet in February 2014:

Veniceland, the Disneyland of the Lagoon, is coming to Italy. On the island of Sacca San Biagio, the roller-coaster giant Zamperla will build a theme park dedicated to the history and culture of the city, in order to remind visitors of a time when Venice was an international economic powerhouse.

The island this article refers to is situated in the Giudecca Canal, only a step away from the Venice we know and love: yet if one wishes to speak about La Serenissima's history, the city itself isn't enough any more. Instead, one needs a Venice

equipped with "educational areas set aside for schools, huge touch-screen displays, performances developed in partnership with the city authorities, a specific area dedicated to the splendid carnival, roller coasters, slides and a large Ferris wheel."

Reproductions of various natural landscapes (the *barene*, or salt marshes) and historical reenactments (the Battle of Lepanto) have been planned, all of which has been granted the seal of approval by the University of Venice, whose rector "offered his university's expertise to the company so that the protection of the city's historical and environmental treasures would be guaranteed. Nobody would think of calling such a place a Luna Park."

Thus, *The Guardian* newspaper was certainly correct when it published a provocative piece in June 2006 entitled "Send for Disney to Save Venice," which argued that if Venice's future lies in cheap, mass-market tourism, then it might as well be entrusted to the Disney Corporation, who would run it better than the city authorities.

No one is safe from such a radical drift. In Pompeii, city authorities are planning a Pompeii Experimental Park, a sort of facsimile of the actual archaeological site, which one can only presume is now deemed too boring. Yet there's nothing new about this idea: back in April 2007, then Minister of Culture Walter Veltroni launched the idea of a Jurassic Pompeii, "made up of gadgets, CDs, recreational areas and virtual games, and created to salvage the deteriorating site of Pompeii, which belongs to our archaeological heritage." All of this would be accomplished in a hurry, of course: according to the minister, it would take only "three years and a special law." Not to mention what Gianni Alemanno cooked up in 2008 when he was mayor of the Italian capital in order to "save Rome from a decline in tourist numbers," namely: "the Disneyland

of ancient Rome, featuring virtual reconstructions that will allow visitors to watch shows at the Colosseum, chariot races at the Circus Maximus, explore the catacombs, or take a dip in the Baths of Caracalla."

Even in their most depraved form—for instance, Venice-land—these new coinages and cultural initiatives are seen by some as a democratization of culture, and anyone who dares question them is deemed elitist. Historian Howard Kaminsky has written that in a mass society our attempts to analyze history have fundamentally changed:

> In resonance with the post-national and post-political mentalities of a mass society, its function is not to impose a new, authoritative story but rather to stock the scholarly section of what can be imagined as a Universal Historical Museum, corresponding to the needs of our time much as do supermarkets, shopping malls, the Internet, multichannel television, and the various postmodern deconstructions of traditional modernity …Disney World [is] … both epitome and major mover of this postmodern drive to reduce our culture from a meaningfully structured system to a decontextualized wilderness of repackaged symbolic forms in no particular order, all to be consumed indiscriminately as commodities … [This] is obviously in line with this *Zeitgeist*, which is a point against it only if one thinks ignoring the *Zeitgeist* will make it go away.

From this perspective, according to the neoliberal mind-set now glorified as our zeitgeist, consenting to the com-

modification of the entire planet and wandering around the cultural artifacts of our past with a shopping cart and credit card are facets of a categorical modernity deemed as inexorable as the passage of time.

This brutal variety of presentism presumes that our era can, and should, be guided solely by a market mentality: and that the crowds which throng our shopping malls are the only possible expression of postmodernity and the apex of its rituals and values, the only measure by which one is allowed to shape both the present and future. Yet why do those who idolize the free market economy place all bets on a single zeitgeist that allows for no alternatives? Why must our mass culture obsess over the repetition of sameness and not further our knowledge of diversity and otherness? Whatever triggered the race to build theme parks and fake residential Venices replete with Rialto Bridges wasn't the democratization of culture, but rather the imposition of a standardized and sterilized version of our past and our diversity. This has nothing to do with the blissful coexistence of multitudes, but is actually the same old habit espoused by the privileged classes who wish to keep the pleasures of what is authentic all to themselves, while offering pale imitations to the masses, paternalistically camouflaging them as gifts. These practices reveal no interest in what is different except from the desire to absorb it, commercialize it, and finally neuter it so that it no longer represents an alternative to the dominant monoculture. *History sells* has been said over and over again, so long as it is attractively packaged of course. So long as it is literally *consumed*.

The very act of selecting a few iconic monuments in order to promote them as the authentic epitome of Venice (nevertheless built on a reduced scale and employing low-quality materials) lays bare the authoritarian mechanism that pre-

sides over these "democratic" practices. There are those who decide which objects are conventional and representational enough to summarize Venice—and then there are those who have to abide by those decisions, or better yet, those who are persuaded to pay for them. This arbitrary selectiveness toward the continuum of art and history has erected a powerful filter that eliminates any notion of complexity and distorts the whole. This filter refuses to recognize diversity, which is the yeast of history and our cultural memory, but instead forcibly annexes what is different to the monolith of the identical. It subordinates what is true to what is false, what is complex to what is simple, the eternal to the ephemeral. It puts on a show of cultural diversity driven by the single aim of a means of virtual simulation, to then sell it, adulterating it in the process. Yet the simulation and the simulacrum are only a step apart. As cultural theorist Jean Baudrillard wrote: "The simulacrum is never what hides the truth—it is truth that hides the fact that there is none. *The simulacrum is the only truth.*"

That such a mechanism of cultural manipulation came into play by cloning Venice from afar (in China and the United States) is now beyond question and will undoubtedly keep occurring. Yet what effects has this had on Venice itself? One would be forgiven for thinking that each new clone would enrich the glory of that city on the Lagoon and its amazing diversity, but this is not the case. The virus of the simulation has wormed its way into Venice and has ensnared it, just like a mirror that swallows up the face of whoever looks into it. Or better yet, like a burning glass that doesn't merely collect light and refract it, but instead concentrates its rays onto a small area to combust and destroy. While Venice's inhabitants continue to flee, thereby depleting the city's civic consciousness

and cultural memory, the Ugly Side of Venice is taking over and entrenching itself, allowing the unthinkable to happen: a fake Venice next to the real one, whereby the truth of the simulacrum shatters and engulfs the truth of history. The planned project of building a Veniceland right next to Giudecca is particularly heinous precisely because it suggests situating the copy right in front of the original; in fact, it actually suggests putting the two in direct competition with each other, thus decreasing the city's ability to tell its own story: by embodying it, and not just mimicking it, to tell a story that is made of stone, and not papier-mâché, that is expansive and not reductive, that is real, and not fictional. Veniceland and its siblings resemble shopping malls, yet this similarity implies that everything has a price, and that anything that can't be sold on the market has no value whatsoever. Indeed, it presupposes that a fake Venice can be more valuable than the real one specifically because it can be marketed and advertised. Yet this specific project is a telltale clue that Venice is losing its own identity, and is trying to find it elsewhere, at an exorbitant price. It's as if this city of such miraculous beauty were becoming invisible to the very people who live in it, or as though its identity were growing weaker with each passing day. Like an old man on his deathbed.

Venice multiplies itself and refracts, like light bounces off the shards of a mirror that has broken into a thousand pieces. Yet in this unprecedented scenario, the city runs the risk of losing its very soul and life force. Instead of validating its uniqueness and indivisibility, it risks slipping into a dizzying confusion of facsimiles. Instead of distilling its resources, ideas, and creativity into the fabric of city life, it risks losing itself in a delirium of imitations. Instead of strengthening its

inhabitants' civic awareness and cultural memory, it confuses elitism with history and popular culture with its own destruction. Yet neither democracy nor policy lies on the horizon, and without a population the city cannot be said to have any citizens. The only thing that will remain is a skeletal, monotonous zeitgeist, a kind of commodities exchange or souk where anything that isn't sold dissolves into nothingness. One can certainly replicate Venice, that's true; one can even pretend to do so in the name of diversity. Yet Venice enjoys an advantage over all its imitations and simulacra: it doesn't *pretend* to be diverse, it simply *is* diverse.

CHAPTER XII

Margins

What does a city contain? There are people and houses, churches and squares, streets and palaces, public and private spaces, voices and lights. There's the big and small; a meager fabric meant only to be short-lived, and splendid monuments built to withstand centuries. There's a private and domestic sphere, and one that is public and representational. There are ritual spaces for politics and religion, then the ones devoted to the market, social interactions, entertainment, sports, schools, culture, justice, and health. Unique in every city, these components interact in different ways, and it is precisely this variety that makes the city the most important, diverse, and promising cultural creation human civilization has ever produced.

Every city is a theater of history and memory, a *Gesamtkunstwerk*, a repository of shapes and patterns, an archive of war and peace—it mirrors politics and stimulates literature; yet each city does so in its own manner, and each city constantly rearticulates itself, reinvents itself, and rises reborn from its own ashes. The city form includes all cities and yet transcends them, resembling no city in particular: there isn't a single city that doesn't have unique features of its own. A thousand changes sketch the imaginary maps of what the city had once been, or what it could be in the future: the Greek *polis* and the Roman *colonia*, the medieval commune and the

ideal city of the humanists; or the Italian, Dutch, American, and Chinese conurbations; trading cities, industrial cities, and postindustrial cities.

Typologies and classifications of all kinds can be found not only in specialist works of literature, but in everyday conversations too. There are nevertheless a few constants in the very idea of the city: first and foremost, the hierarchy of spaces and their distinctive functions, what Henri Lefebvre once called "the production of social space." This is the result of economic, political, and cultural processes, guidelines that combine to alter the balance between the public and the private, the secular and the religious, the functional and the symbolic. Over time, each city produces its own expression and meaning of space, which mirrors the invisible city, with its unique stories, insights, and rituals. Urban spaces both surround and shape their citizens' bodies, invade their memories and reflect their values and thoughts. The visible and invisible cities interpenetrate one another, as is the case with the body and the soul. It is of vital importance in our times that everyone who lives in a city's body fully participates in its public life, even newly arrived immigrants, the new Europeans of tomorrow.

A second constant in urban spaces is that its limits are defined, a boundary where the city ends and something else begins. The historic city is finite by its very nature, regardless of whether it is encircled by walls. Romulus plowing his furrow around Rome's future site has all the demonstrative force of an *exemplum*: the city is what it is because it began in a fixed point in time and is confined by boundaries in space. Because a city was founded on a specific day, employing specific gestures and rituals, and was inspired by a specific urban plan, built upon the premise of a prophecy (or conjecture) about its ideal dimensions. Every city's successive enlargement (in

Rome's case, the ancient Servian Wall, the Aurelian Walls, and finally the Great Ring Junction highway built after World War Two) correspond to new limits, hypotheses, or diagnoses about the life of a city as an organism composed of people and buildings. Yet as Lefebvre noted, the social space of the city "installs itself on top of nature": the city finds its boundaries neatly demarcated by the countryside, by the natural space it carved out for itself and which remains its necessary horizon.

The historic city is defined by a double relationship: with the human body (belonging to the citizens who inhabit that city) and with nature (the surrounding countryside). The aspect ratio of a citizen's body automatically designates what is small in that city (a house) and what is big (the palaces of power, the temples of worship, the shrines to the market). The architecture of power—or subjugation—from the ruler's palace to the skyscraper belonging to a bank or corporation lays bare the intent to tame an individual's body and willpower by generating a feeling of subservience. The nature which surrounds the city favors the big, in fact it favors the gigantic, all because, as Princeton Professor of English Susan Stewart writes:

> Our most fundamental relation to the gigantic is articulated in our relation to landscape, our immediate and lived relation to nature as it "surrounds" us. Our position here is the antithesis of our position in relation to the miniature; we are enveloped by the gigantic, surrounded by it, enclosed within its shadow ... We move through the landscape; it does not move through us. This relation to the landscape is expressed most often through an abstract projection of the body upon the natural world.

Yet the gigantic in nature belongs to everyone, and thus rebalances the equilibrium between nature and culture, which is constantly undermined by the hierarchy of urban architecture.

The margin, where the city ends, is essential because it provides that entity with both cohesion and meaning, but also because it represents the limit vis-à-vis natural space, the horizon of radical equality. For centuries, the urban margin in the Italian tradition was tied to the concrete experience of the citizen, who as he went back and forth from the countryside, lived it as a slow (and almost imperceptible) transition. The strengths of this natural shift lay in both the admirably sculpted aspect of the landscape, insofar as it was forged by man, as well as in the pronounced compactness of the image of the city, which had to be visible from afar. This also explained why it was forbidden to build anything within a vast belt outside the city walls, as exemplified by laws passed in Florence in 1531 and in Naples in 1566.

The elimination of urban frontiers, which began with the systematic destruction of many cities' walls, like in Florence, Modena, and Forlí, from the late 19th century to the early 20th century, triggered a dramatic reversal of perspective. Shapeless peripheries grew around our cities, spreading like wildfire, "squeezing the historic centers in a deadly vise and triggering a significant deterioration," in the words of historical restoration specialist Bruno Zanardi. These days, a fifth of all Italians—and in the future this will expand to a third—live in environments where the hierarchy of space, the coexistence of the public and private spheres, the big and the small, the past and the present, the cultural and the natural, have all been banished. Fossilized remains of the ancient landscape have survived here and there, but even the most archaeologically-minded are not aware of

where the city and the countryside meet. Supplanting civic consciousness and collective identity, the new suburban fabric is subject only to the rules of property revenues and real estate speculation. It's time to "limit the endless expansion of suburban sprawl by returning cities to their margins," as Zanardi has written, while at the same time "soldering the historic center to its periphery" and reestablishing the connection between the city and its citizens.

Unique even in this respect—or rather, the supreme example of this—Venice still lies within its watery walls. This was how they were described in the *Edict of Egnatius*, a 16th century Latin inscription housed in the Museo Correr, and which is attributed to a humanist named Giovanni Battista Cipelli, known as Egnatius (1478-1553), and a friend of Erasmus and Aldus Manutius:

> By Divine Providence, the city of the Veneti is founded on water, surrounded by water and protected by water instead of by a wall. Hence, whoever dares in any way to damage the public waterways, let him be condemned as an enemy of the Fatherland and punished no less gravely than someone who has undermined a city's walls. Let this Edict remain in force immutable and perpetual.

The solemnity of his language, his use of Latin, and the fact that it was engraved in capital letters on a slab of marble make this a very unique inscription, so much more so because even though it wasn't one of the Republic's official documents, it was still put up in the offices of the *Magistrato alle Acque*, the

Water Authority. Regardless of what that document's original aims were (a humanistic fabrication, perhaps written to sound like an imperial edict?) it helps us to understand the unique nature of both Venice and its margins: the Lagoon.

Venice's social and cultural space, with its density and unparalleled originality, would be unthinkable without the symbiosis between the city and the Lagoon. The language of space is a "code at once architectural, urbanistic and political, constituting a language common to country people and townspeople, to the authorities and to artists—a code which allows space not only to be 'read' but also to be constructed," writes Lefebvre—and in Venice's case this isn't only part and parcel with the Lagoon, but it comprises the entirety of the city's cultural, artistic, religious, and economic life, on both land and water. Enclosed inside its lagoon like a pearl within its oyster, Venice has never seen the Lagoon as either an obstacle or a neutral space. Looking at La Serenissima's laws over the centuries, it is evident that the city, islands, and lagoon formed a single, unparalleled ecosystem that struck a balance between the natural environment and its human inhabitants. The Lagoon was the foundational basis of the city, and over time, it changed with it, reflecting its beauty and history, becoming a sort of counterpoint to it, without which even Venice's voice might one day fall silent.

Thus, starting from the 16th century, Venice's cartography shows the city at the center of a littoral cordon separating it from the open sea, a lagoon dotted with islands, each with its own fields and bell towers. Thus, the Magistrato alle Acque, set up in 1505, relentlessly ordered the excavation of canals and inlets or redirected bodies of water. Yet the ancient balance was upset by the combined effects of industrialization and housing developments in Marghera and Mestre (which

104 | Salvatore Settis

has caused the depletion of aquifers), the subsidence of the sea floor, the creation of navigable waterways, among which are the *Canale dei Petroli*, the oil tanker canal, and the erection of barriers between the Lagoon and the mainland. If we don't wish to keep *Misreading the Lagoon* (which was the title of a book by Lidia Fersuoch) it will be vital to halt this deterioration by safeguarding what remains, beginning with the sandbanks, the semisubmerged stretches of land that regulate the tides and provide a home to rich vegetation, which are able to regenerate themselves by absorbing the suspended sediments in the currents. Nevertheless, many islands in the Lagoon today—such as Madonna del Monte San Giacomo in Palude, and San Giorgio in Alga—are completely abandoned and reduced to ruins.

Will Italy's metamorphosis from a land of cities to a nebulous land of suburbs eventually erode Venice's uniqueness? The bureaucratic invention of "metropolitan cities," which was even enshrined in the Italian Constitution thanks to the amendment to Chapter V introduced in 2001, sanctions the triumph of urban sprawls and indeed promotes it as a critical part of the country's residential fabric. Yet we went even further than that, to the point that we created neosuburbs that usurp the name of the city and whose sole purpose is to legitimize the death of the historic city. This was how after the natural disaster that hit the city of L'Aquila, politicians cynically turned the city into the site of an experiment, which didn't only destroy the city's historic center, but its soul and sociability too. In order to carry out this task, a new vocabulary was used, which labeled the housing blocks which had sprung up around the city in the wake of the April 9, 2006 earthquake as "new towns."

Just like many other cities, L'Aquila was born out of the confluence of various scattered settlements when, in the mid-

dle of the 13th century, the many castles dotting the Abruzzo region decided to found a new city in order to organize themselves more vibrantly. There is a beautiful Greek-derived word that aptly sums up this process of aggregation: *synoecism*, from *synoikismos*. Here we can recognize the word *oikos*, meaning an individual's house, but which also designates the community's house, which belongs to everyone and which lies at the root of words like ecology and economy. According to history and various myths, synoecism—the amalgamation of villages in ancient Greece into *poleis*—led to the creation of cities like Athens and Rome. L'Aquila, however, was the supreme example of synoecism in the Italian Middle Ages, where according to legend ninety-nine castles merged to found the city and preserved their original core identities through the building of churches, or the names of streets and neighborhoods, thereby imprinting themselves onto the collective consciousness as part of a historical and civic process that helped define the European idea of a city as a community of lives, economic activities, and cultural practices.

This noble history wasn't destroyed and disfigured by the earthquake, but by men. In the wake of the natural catastrophe, it was deemed necessary to relocate residents out of unsafe buildings in the historic center. In similar cases in the past, the local population stayed in temporary dwellings while simultaneously rebuilding the ruined city. Yet in L'Aquila's case, the exact opposite occurred: the historic city was emptied out and left to an uncertain fate, while nineteen new satellite cities were built on its outskirts, nonurban sprawls completely devoid of bars, kiosks, squares, schools, churches, or public meeting places. These bedroom communities, hastily erected on agricultural land, contained a range of apartments loaned to the displaced, provided of course that they gave up the right

to ever return to their original homes, or even to bring any belongings, including a bed or a table, to their new homes, which were already equipped with loaned furniture, thereby completely tearing the city's social fabric asunder. This amputation of memory and sociability was part of a conscious plan: to abandon the historic city center in order to build permanent new cities that are actually noncities.

What remains of L'Aquila today is a depopulated city center where a few monuments are being sporadically restored, but the homes remain empty, turning the ancient process of synoecism completely on its head. This disintegration of the urban and social fabric can also best be summed with a Greek word: *exoikismos*. This is a biblical and patristic term used to designate the Jewish Diaspora (in Latin this is called *transmigratio*). The corresponding verb, *exoikizo*, was used— for instance by Plato—to denote the political act of driving inhabitants out of their cities, and can thus be also used metaphorically. In his *Gorgias*, Plato says that the truth can also be banished (*exoikistheisa*) from a city.

Words are avowals, words are confessions, words are stones. What are "new towns"? Why was the English term used in Italian political parlance? This isn't only to pay tribute to the dominant language of our time; the use of this expression—the same one employed by the Aqualta 2060 project which aimed to build a ring of skyscrapers to fence Venice in—betrays something even more offensive. The new towns were in fact an interesting urban planning experiment triggered in Britain by the New Towns Act of 1946, which developed the ideas first laid out by Ebenezer Howard's garden city movement in 1898. The first British new towns were settlements with low population densities built around London to contain growth and urbanization. They were conceived as places where social life

might unfold, replete with commercial areas, social services, parks and residential neighborhoods, where each house had its own garden. Public transport links that quickly connected these new garden cities to London were put into place and a harmonious relationship between the city and the countryside was envisioned. This experiment made waves in Italy, also partly thanks to a 1964 Italian translation of Lloyd Rodwin's 1956 book *The British New Towns Policy*.

As we can see, in London's case the city and countryside were integrated, while in L'Aquila's, the countryside was simply destroyed. In London's garden cities, public green spaces were carefully balanced out by private areas, whereas bedroom communities were randomly built in L'Aquila. Social spaces were designed in London, while communal life in L'Aquila was completely eradicated. A sad fate if one considers that L'Aquila's medieval statutes called for its citizens to build squares, fountains, and churches and put them to collective use before focusing on their individual homes. The contrast between 13th century medieval norms and the barbarism of the new towns requires no elucidation, yet the very appellation—new towns—is both erroneous and blasphemous; in fact, the post-World War Two British experiment more closely resembles 13th century L'Aquila and not its 21st century incarnation. Yet even Italy's history betrays some positive precedents, like Alessandro Rossi's village in Schio (1870-72) or Crespi d'Adda (1875-93) and San Carlo Solvay (1922), all equipped with schools and social services; and when Italian oil and gas company Eni S.p.A. set up its headquarters in San Donato Milanese six miles southeast of Milan, the new city featured "three-bedroom houses for the workers, tennis courts, pools, a stadium, a church and a little zoo for the children," according to the firm's president Enrico Mattei. This all took place in

poor, postwar Italy, yet it still nurtured a memory of itself and looked after its own citizens. It looked ahead to the future, and unlike today's Italy, it could create both jobs and prosperity.

Like the new towns in the Abruzzo, hundreds of suburbs in perpetual expansion and decomposition have been reduced to mere dormitories, thanks to the absence of public places and the lack of any communal life. Will this also happen to Venice? The idea of fencing the city built on water inside a prison of skyscrapers isn't the only move to possibly degrade the city into a fossilized relic of a bygone way of life. We have witnessed Venice's historic center lose its inhabitants, with massive population exoduses to the mainland periphery which mushroomed almost overnight. We have witnessed strong consideration of the idea of turning Venice into one of many neighborhoods of a vast *Veneto City*. We've witnessed heated debates over whether to build the tallest skyscraper in Italy in Marghera. We have witnessed the city being invaded by cruise ships, the skyscrapers of the seas that plague Venice and its lagoon daily. These and other icons of a soulless modernity that has no future now threaten the city once called *La Serenissima*. If we're not able to save Venice, together with its waters, its center and its outskirts, its ecosystems of sandbanks and the history of its doges, with Titian's art and its ramparts of the sea, then this will be Venice's fate: a theme park at its very heart, a Disneyland for tourists and at its edge a nondescript nonplace, a new town on the mainland. And to think that Marghera was planned by Pietro Emilio Emmer in 1919 as an English-style garden city, meant to complement and balance out the industrial site. Nowadays, the deterioration of Marghera's industrial zone has been used as a pretext for cures that are worse than the disease itself.

As Orhan Pamuk writes in *The Innocence of Objects*: "It

seems that there is no way we can discover the secret of objects without heartbreak. And we must humbly submit to the truth of this ultimate secret." Thus, perhaps it is time to listen to Venice's broken heart before this particular destiny is fulfilled. Before it's too late.

CHAPTER XIII

The Right to the City

How would our lives change if we knew for certain that a giant asteroid would crash into the Earth and wipe out humanity only a month after our death? Or if we knew that the entire human species would become suddenly sterile tomorrow and thus doomed to extinction? Would this change our daily actions and the values that shape our choices, and how? We all know that our own death is inevitable, but how would each of us change if we realized that the entire human species would disappear into nothingness? These are questions philosopher Samuel Scheffler identified in his recent book *Death and the Afterlife* and which he discussed with great urgency and eloquence:

> In certain concrete functional and motivational respects, the fact that we and everyone we love will cease to exist matters less to us than would the nonexistence of future people whom we do not know and who, indeed, have no determinate identities. Or to put it more positively, the coming into existence of people we do not know and love matters more to us than our own survival and the survival of the people we do know and love.

Whether we believe in the immortality of the individual soul, our civilization is built upon what Scheffler calls our *collective afterlife*, a collective life that lies beyond our individual deaths, or, as Thomas Nagel writes in a review of Scheffler's book, "the survival and continued renewal of humanity after our personal death—not only the survival of people who already exist, but the future lives of people born long after our deaths." If we spare such little thought to the enormous importance of this collective afterlife, it's only because we take it for granted: yet the inner experiment of picturing the end of humanity can help us to realize its magnitude.

Scheffler's collective afterlife offers a new perspective from which to discuss the rights of future generations. This perspective can seem peppered with apocalyptic thinking, but it isn't: it invites us to exercise our minds—or can be seen as a gymnastics of feelings and emotions—which reminds us that much of what we think and do can quickly lose all meaning and become impractical if it isn't—more or less consciously—oriented beyond our individual lives. Whenever the rights of future generations are discussed, the dialogue is often restricted to ethical, judicial, and political aspects (solidarity between generations, the common good, individual and social responsibilities, etc.); it's what I did too, for instance by referring to Nietzsche's "love of the distant," or Hans Jonas's *Imperative of Responsibility* in one of my recent books *Azione poplare (Popular Action)*. By stressing anthropological structures and individual and social psychology, Scheffler shifts the argument from the domain of ethics to that of ethology, and recognizes in social behavior a component that is necessarily oriented toward the future. The voracious presentism that has ravaged cities and landscapes in the name of profit is thus to be understood as a social pathology, which should be cor-

rected by an education that values the ethic of responsibility and enforcement of the laws.

Designed to accommodate a social way of life and built to last, the city is the appointed optimal place for the planning of the future. Thus, the dissolution of the historic city, and the one-track thinking of the megalopolis, and the abolition of the diversity of urban models have affected the behavior of men and women, imposed new ways of practicing one's citizenship, and profoundly transformed not just cities themselves, but also all kinds of public discourse on subjects like democracy, economics, and inequality. This explains why the biggest popular protests in recent years, from Istanbul to New York, have assumed a distinctly urban character. Protesting in the city, for the city: the right to the city as a theater of democracy is a central part of this new awareness; the city as a kind of balancing act between the fabric of streets and architectures and the dignity of individual citizens.

Almost fifty years since the publication of Henri Lefebvre's *The Right to the City* in May 1968, shortly prior to the student riots in Paris, this sort of thinking was in dire need of a radical reconsideration due to the devaluation of the urban form and the rise of immense conurbations. David Harvey's 2012 book *Rebel Cities* offers us a framework of descriptive categories in order to define our right to the city, through the concept of the common good and a new dimension of a citizenship aware of its inalienable rights: the first step to understanding how these rights are trampled, and by whom, as well as the first step to winning them back. Having been founded and expanded because of its implicit value, the city reflects the shape of its society. Thus, as Harvey writes, "in making the city man has remade himself." Nevertheless, the commodification of the world has jettisoned this original value and converted it into

exchange value: the city is worth only what it can bring in, meaning that it is therefore for sale. Urban civilization is in actual fact an ecosystem that creates patterns of behavior and ways of life that produce a set of objects, values and practices that even impact nonurban areas (like the mountains or the countryside, etc.). Urban civilization is contagious.

The borders between the city and the countryside have grown ever more porous, but this process has produced two opposite reactions, which shouldn't be confused. On the one hand, the metastasizing of cities, which in countries like China has seen countless multitudes urbanized, has triggered the dispersion of the urban form, leading to a topography of social and environmental inequalities. Furthermore, in order to abide by this model of development, even historic cities have been suffocated by squalid suburbs. The explosion of megalopolises has neatly coincided with the implosion of historic cities. The horizontal city grows in on itself, spreading like wildfire, or lava. It swallows up the old countryside, leaving massive residue in its wake which is neither suitable for agriculture nor habitation, a gray zone, a no-man's-land. This is what botanist Gilles Clément has called the third landscape, a "place of indecision" that also plays host to insecurities and collective and individual tensions.

On the other hand, however, the interpenetration of the city and the countryside can forge a culture of transition that enables a strong bond between citizens who live in the countryside and farmers who use urban technologies, as is the case in Holland. This is what Rem Koolhaas has termed the *Intermedi-stan*, a land of the in-between, neither rural nor urban. In these areas, some agricultural activities—which have grown increasingly reliant on technologies—persist in the midst of an urban fringe of people looking for a more authentic way of life.

The nine thousand-acre strip that Koolhaas analyzed is situated between Amsterdam, a historic city, and Stad van de Zon, a new town that was officially opened in 2009 (Stad van de Zon means City of the Sun, meant to be a nod to solar power rather than to 17th century philosopher Tommaso Campanella's utopia).

Analyzing and managing these developments is an urgent task that today's urban planning does little to address. The original sin of the Italian system—largely caused by the remnants of fascist-era legislation that survived and were even enshrined in the constitution—is the lack of coordination between zoning laws and the protection of landscapes. Just as I attempted to show in my own 2010 book *Paessagio Constituzione cemento* (Landscape, Constitution, Cement), we ended up almost pretending that Italy was a nation of landscapes without cities and cities without landscapes (Just imagine!). The result would be a chaotic "third landscape" and not a planned Intermedi-stan: meaning a colossal waste, and not just another failed opportunity.

In a world in constant flux, the right to the city is therefore also a right to the countryside or nature. It must hinge on the city as a *space for mediation* since as Lefebvre writes, it is:

> situated at an interface, halfway between what is called the *near order* (relations of individuals in groups of variable size, more or less organized and structured and the relations of these groups among themselves), and the *far order*, that of society, regulated by large and powerful institutions (Church and State), by a legal code formalised or not, by a "culture" and significant ensembles endowed with powers.

However, the shape of the historic city also has to do with space and the mediation apparatus between the individual's body and society's body. The body of the historic city is compact, recognizable, and meaningful; it is a finished thing, and yet it expands like a living organism; it's permeable, it allows you to walk through it, understand it, memorize it. It calls out for hierarchies of power and values, but it consents to changes; like a language, it welcomes new additions while retaining its own structure. The body of the city is a topography of recognizable and codified diversities: thus it helps people navigate its streets. It suggests uniqueness, dignity, and identity, but forms a dialogue with other cities (other identities, other forms of uniqueness); it embodies successive generations and evolving institutions; it stimulates debates and invites one to become familiar with it. According to the admirable words enshrined in Siena's constitution from 1309:

> Whoever rules the City must have the beauty of the City as his foremost preoccupations: and in fact our City must be honorably decorated and its buildings carefully preserved and improved, because it must provide pride, honor, wealth and growth to the Sienese citizens, as well as pleasure and happiness to the visitors from abroad.

There exists a relationship of proportions and measurements between the body of the citizen and the body of the city. In a historic Italian city, the looming sight of a bell tower, or a cathedral, or a palace belonging to the commune or the local lord, the dense structures of convents and universities, and the façades of the richest houses are all intertwined with artisanal workshops, impoverished neighborhoods, the alleys

of marketplaces, and the roads that lead to graveyards and mountains, the gates and the walls: they welcome citizens, but they don't swallow them up. Sometimes they dominate the citizens, but they never humiliate them; they proclaim social hierarchies, but also provide public places like squares and covered markets in the name of equality, markers of stability that also allow for social mobility. The body of the city and the body of society aren't at war with each other, but instead mingle and communicate. Thus, the city is a work of art and not just a material product. A city is born out of the construction of walls, churches, and houses, but also out of culture and social relationships. It breathes and grows alongside the citizens who have created it and will change it over the course of time, so that the city feeds on their flesh and blood and in return provides us with its rituals, which aren't timeless because they're always the same, but because they're subject to continual changes.

If discussed as a social need, the right to the city has its foundations in anthropology. As Lefebvre writes, the historic city:

> includes the need for security and opening, the need for certainty and adventure, that of organization of work and play, the needs for the predictable and the unpredictable, of similarity and difference, of isolation and encounter, exchange and investments, of independence (even solitude) and communication, of immediate and long-term prospects ... Would not specific urban needs be those of qualified places, places of simultaneity and encounters, places where exchange would not go through exchange value, commerce and profit?

The historic town is a horizon which embodies the exchange of experiences, cultures, and emotions, which can occur thanks to the place, and not the price. In the end, the right to the city and the right to nature aren't merely complimentary: they're the same thing. In the culture of transition typical of Intermedi-stans, the right to urban life means a right to change it according to plans that recognize the city as a cradle of otherness and the home of diversity, made up of what David Harvey calls "liminal social spaces of possibility where 'something different' is not only possible, but foundational for the defining of revolutionary trajectories."

Being the combined creation of all social classes, as Harvey notes, the city is by its very nature founded on the principle of work: the work of past generations, and on the capacity to provide work for future generations. A microcosm and a crucible of thought, the city feeds on its own diversity: its internal lack of homogeneity increases its anthropological depth, capturing the attention of its citizens and visitors and stimulating their experiences. Even buildings that have become "useless" over time, like the Colosseum in Rome, aren't actually all that useless; they embody profound historical changes, force one to think about alternatives, and help nurse a desire for what is culturally different, namely other civilizations. In stark opposition to the monoculture of the dull global city engulfing the planet, the historical city is a thinking machine. It enables us to think about something other than ourselves, and thus helps us learn about ourselves in the process.

According to Harvey, the "right to the city" popular movements have their roots in Brazil and from there spread throughout the rest of the world, from Zagreb to Toronto, from Hamburg to Los Angeles, from Bangkok to Mexico City,

and from Athens to Paris. Occasionally, these movements have assumed the aspect of urban riots caused by marginalized groups that have occupied key areas of their city, "seeking to reclaim the city they had lost ... to define a different way of urban living from that which was being imposed upon them by capitalist developers and the state." Thus, the movements claim collective ownership of the city and reject expropriations in the name of profit, demanding the democratic management of their city and an emphasis on the common good.

Popular protests and an active debate on law and ethics led the Brazilian government in 2001 to explicitly recognize the right to the city, which:

> guarantee[s] the right to sustainable cities, understood as the right to urban land, housing, environmental sanitation, urban infrastructure, transportation and public services, to work and leisure for current and future generations; democratic administration by means of participation of the population and of the representative associations of the various segments of the community in the formulation, execution and monitoring of urban development projects, plans and programs.

The general idea, forcefully outlined in the Brazilian Constitution, "is aimed at ordaining the *full development of the social functions of the city* and ensuring the well-being of its inhabitants," establishing the public interest's priority over individual rights, as well as enshrining the use-value of space over its exchange-value.

The right to the city movements in Brazil were able to rely

on the constitutional recognition of the social functions of property, which were already addressed by the 1988 Constitution (Art. 5, xxiii). Yet this particular subject has a longer history in some European countries. Consider Article 153 in the Weimar Republic's Constitution of 1919: "Property imposes obligations. Its use by its owner shall at the same time serve the public good." This proved to be the starting point for an impassioned debate in the Italian Constituent Assembly (which I discussed in my own book *Azione populare*) which eventually led to Article 42 of Italy's current constitution: "Property is public or private. Economic goods belong to the State, to entities or to private persons. Private property is recognized and guaranteed by law, which determines the ways it is acquired, enjoyed and its limits in order to ensure its social function and to make it accessible to all." Paolo Taviani, a Christian Democrat deputy in the Constituent Assembly, cited the German precedent:

> goods produced by the soil are to be destined for the common good above private property; at the basis of the natural economic order lies the social right of all people to use common goods and the Constitution must sanction the rational valuing of the national territory in the interest of all its people, so as to create the basis for more egalitarian social relationships.

As former Supreme Court judge Paolo Maddalena showed in his recent book, *Il territorio bene comune degli italiani* (Territory as Shared Asset of the Italians), this is an issue of supreme importance.

In Venice, which Lefebvre called "unique, original and primordial," even disorientation becomes a virtue: losing oneself in its labyrinthine alleys, far from the beaten path, allows continual discovery of beautiful new spots and historical monuments, new pearls of diversity in inexhaustible abundance. The body of the city mimics, repeats, and enhances the citizen's body: it welcomes and guides him, echoes his voice and steps and leads him to streets and bridges, canals and squares, with a rhythm and flow more harmonious than anywhere in the world. It is a collective creation brought about not only by the Doges and the Council of Ten, the aristocrats and merchants, but also artisans and sailors, glass workers and gunsmiths, men and women, Venetians and Slavs, Greeks and Jews, priests, painters, musicians, carpenters, and lawyers. Venice conquered the right to the city for those who dwell in it, which in this city, above all others, also means a right to nature, a right to the well-being of the Lagoon which has been integral to Venetian life and history for millennia. Nevertheless, the Lagoon's remarkable protective barrier has failed to halt the plague now afflicting historic cities. Even Venice has been mortally wounded by the process of suburbanization that empties cities of their inhabitants, reducing their social diversity, increasing inequality, and relegating their young and the have-nots to the outskirts. Even in Venice's case, to speak of a right to the city means to actively oppose the process which has made historic cities fair game for real estate speculation and uncontrolled architectural experiments. Even in Venice, the health of democracy is determined by how successful citizens prove in defending their rights, which include the common good and the social functions of property. And a city without a right to the city is a city without citizens, an empty husk.

CHAPTER XIV

"Civic Capital" and the Right to Work

Whenever one talks of the common good or of the public interest, conformists incapable of thinking on their own often repeat the same rehashed mantra: in times of economic hardship money is the only thing that matters, while everything else is a luxury (even rights). This being the case, let's try for the sake of argument to reflect on the right to the city within the language and terms employed by the market economy. We'll do so from two converging points of view: monopoly rents and civic capital.

Every city wants to enhance and increase its attractiveness and its capacity for creativity; and in a world dominated by competition, it aspires to be unique, special, better than all the others, placing its symbolic capital on display for all to see. Every city should try to preserve its uniqueness, and to think of that uniqueness as a monopoly that no other city in the world could appropriate for itself, and this idea should only grow stronger the more unique its features are. Yet in order to preserve its own uniqueness and project it into the future, one must first get to know it and think of it as indispensable. Conversely, our ever greater ignorance has overturned our hierarchies of values and thus we don't prize the uniqueness of each city, but rather the homogenization of all cities, following a mentality nourished by the fetishes of globalization, a mentality that wants all our cities to look identical (there are hotel

chains that boast that their conference rooms are the same in Singapore as they are in Lisbon, all with the same layout, the same paintings on the walls, the same furniture, coffee cups, and glasses). Harvey has noted that this masochistic desire for sameness in the name of modernity (i.e., the market) is currently eroding even the identities of cities like Barcelona and Berlin with strong historical and cultural traditions.

Symbolic capital and monopoly rent are merely convenient expressions, metaphors that can encapsulate fashionable phenomena in a few words even though they are actually quite complex (this is how Harvey uses them in his *Rebel Cities*). They shouldn't be taken too literally even though they have something very important to say: the forced homogenization of our cities, which tends to neutralize diversity, is a serious mistake even from a market point of view. Citizen associations fighting against the demolition of an old historic neighborhood or the closure of a theater are doing more for their city—in strictly economic terms—than those who wish to take possession of those places in order to standardize them. As such, citizens have a right and a duty to oppose anyone who wants to squander the symbolic capital that their fellow citizens spent centuries accumulating through their hard work; they have a right to do so not only in the name of the past, but of the future too.

Losing all self-awareness, cities have joined the race to brand themselves, a recent kind of business that closely resembles the competition between fashion houses, wineries, factories, etc. There are experts who can come up with trademarks for ancient locales, and all in no time too. They parachute into places they know nothing about and come up with a slogan, a logo, and a launch strategy, none of which vary much from city to city. The symbolic capital that each city has accumulated throughout its history, thanks to the hard work and creativity of its inhabitants,

is thus completely squandered and replaced by glib formulations improvised on the spot. This might be understandable when it comes to cities with more recent histories or less well-defined identities, but this kind of branding certainly isn't understandable for historical cities with stronger personalities. And yet even Venice's reputation was stained by such a foolish quest to find a new identity when in 2002 city authorities unveiled an international competition to come up with a municipal logo, with the aim of "defending Venice's identity and expressing its ideas." The announcement pointed to the example of New York as the Big Apple, and the jury that awarded the prize met in New York, not Venice. In fact here is what an enthusiastic commentator by the name of Nicolò Costa had to say:

> from New York one can consider the international demand for culture-based travel in order to show that behind that logo lies the real Venice, which can revitalize itself within the confines of the modern economy ... the invention of a logo is part of an urban marketing strategy that can be leased to commercial interests in return for additional financial resources ... The citizens of Venice are the stakeholders that link tourism to the values of the hospitable city both for their sake and the tourists'.

From this point of view, anyone who criticizes this initiative is an elitist, unlike Venice's mayor at the time, Paolo Costa (currently the manager of the Venice Port Authority) who apparently, according to Nicolò Costa, believed in the "educability of the masses." Once the competition stopped accepting new entries, a logo designed by Philippe Starck was chosen

(a mangy lion depicted in profile with only a single wing out-stretched, a giant *V* in the background), and when it became clear that additional funding would not be forthcoming, instead of owning up to the inanity of the whole exercise, the new city authorities instead decided to hold another competition in September 2012 to design a new logo, as though Venice were forced to come up with a new logo every ten years, or every time it elected a new mayor. Thus, even Venice can relinquish its solid monopoly in order to beg for a mercenary sort of *branding*.

And what about social capital? First let's start with human capital, which became a widespread notion especially following the 1964 publication of Gary Becker's *Human Capital*, which aimed to fix the market value of human beings and their work by relating it to the profit of various enterprises, in order to guide their wage policies and their insurance coverage, health-care, and pensions. A very difficult task indeed: Can one truly put a price on the expertise, experiences, sociability, and creativity of the average worker? It's certainly possible to measure the productivity of workers in a factory; but human capital is also composed of factors that are both unmeasurable and variable, just like the individual character traits of each worker, whose experience and competence—but also their emotions, thoughts, aspirations, flashes of genius, and psychophysical breakdown—can grow (or not) over time. Human capital isn't a manageable commodity; and much of what is left out of any quantification usually has a *collective* aspect to it, meaning that it doesn't only belong to the individual but to the society (and *city*) to which said worker belongs and whose values and memories it shares.

These are the aspects that sociologist Pierre Bourdieu has attempted to address since the 1970s by encapsulating them in the term social capital: "Social capital is the sum of the resources,

actual or virtual, that accrue to an individual or a group by virtue of possessing a durable network of more or less institutionalized relationships of mutual acquaintance and recognition."

Having been accumulated collectively, social capital stimulates individual creativity, but it channels the resultant skills and products into the community (the city) to which that individual belongs. The recent definition of *civic capital* suggested by Luigi Guiso, Paola Sapienza, and Luigi Zingales in their 2010 paper "Civic Capital as the Missing Link" marks a leap forward: "civic capital, i.e., those persistent and shared beliefs and values that help a group overcome the free rider problem in the pursuit of socially valuable activities."

Civic capital is persistent because it is rooted in the mechanisms of intergenerational transmission that work on a large scale (families, schools, society). Thus, it's something more than social capital insofar as it includes the notion of civic culture, a collective set of values, principles, and social memories that have cultural, political, and social dimensions.

> Civic capital does not depreciate with use (in fact it can appreciate with use), but it can depreciate with age, both for the obsolescence of the knowledge accumulated and for the obsolescence of the brain that acquired it … Even more than physical and human capital, civic capital takes time to accumulate and has increasing returns to scale … It is a leading potential explanation for persistence in the level of development observed around the world.

This approach has the advantage of looking at the complexities of human society from a purely economic point of

view, using that as a starting point to discover other hierarchies of values; yet it stumbles when it attempts to quantify civic capital by trying to accurately measure the culture (and soul) of all men and women. Capital, monopoly rent, and various other terms of that sort can be useful metaphors, but they quickly become a trap for anyone who takes them too literally. It would be far more sensible to investigate another thread, in other words the strong link between civic capital and a given community's political history. This is a topic that was already explored by Robert Putnam in his 1993 book *Making Democracy Work: Civic Traditions in Modern Italy*, which sought to discover the roots of the economic and cultural difference between the North and the South. Let us therefore try to think of a civic capital that can be understood only by examining the stories, experiences, and actions of citizens associations, which usually coincides with the symbolic capital of their respective cities. We will see that it hinges on urban culture, the shape of the city, art, languages, music, religion, ethical horizons, the duties/rights ratio, social responsibilities, and the desire to have a good life. These are all immeasurable by their very nature and they are all essential ingredients of the right to the city.

Every citizen has an individual stake in this, but the right to the city is in itself collective, and belongs to the community as a whole. This principle is rooted in the long collective creation of the city, which took over a thousand years in Venice's case; it is also rooted in the fact that it is geared toward our collective afterlife for future generations. As workers of the present and creators of the future, citizens today have to live not only in their own city, but *with* the city, better yet they have to *give the city life*. Because even though their rights are centuries old, the urgency of the moment dictates that they radically reassert them. This doesn't translate into a right to

halt progress, but to make sure that progress conforms to the common good, whereby we should not passively preserve, but rather respectfully make necessary changes; not to place the city in a stasis chamber, but instead ensure its mutation without betraying its DNA. This right to *rethink the city* must rise to the toughest challenge: fighting against a process of homogenization that is annihilating uniqueness.

The right to the city must attach itself to the social functions of property enshrined in Italy's Constitution even though a string of bad national policies has allowed us to forget how important this is. The social functions of property and the right to work are closely interlinked not only from a legal point of view, but also from an economic, ethical, and practical one too. In fact, even the right to work is emphatically stressed in the Constitution. In Venice's case, the work available to local residents can't be restricted to the tourist monoculture, but has to be worthy of the immense civic capital the city has accumulated over centuries. The social function of property, regardless of its ownership, can't be solely determined by increasing real estate value while decimating the local population and condemning the city to die. It must nurture creative and productive enterprises, repopulate the city with young people, and loosen the tourist monoculture's stranglehold. Anyone who fights for Venice armed with the Constitution is automatically fighting for Italy as a whole, and for the future of other historic cities too. In order to keep the city alive and increase its civic heritage, Venice's future generations must be ensured social dignity and personal development. This is the only way for the city to be re-energized by fresh ideas, young citizens, and projects for a better future.

CHAPTER XV

Spaceships of Modernity

Toward the end of the 19th century, a phenomenon which anthropologists later called cargo cults began to spread, first in Melanesia and Micronesia, then to other parts of the so-called underdeveloped world. The cargo cults loosely described a group of magic-religious practices which involved praying to a higher entity for the gift of goods like those found in wealthier societies. Having come into contact with ships—and later planes—loaded with technologically advanced consumer products, and not having any idea as to how these were obtained, some tribal societies believed them to be gifts from ancestors or gods and subsequently developed worship rituals to be blessed with these rewards. After World War Two, the priests and prophets of the cargo cults invented mimetic customs, building rudimentary runways for airplanes and control towers, or life-size replicas of planes and other objects (radios, weapons, telephones) which they'd seen American or Japanese soldiers use, or by imitating their drills and military salutes, which they'd assumed were propitiatory acts. Usually triggered by something a member of their community had witnessed, cargo cult rites implored ancestors to bestow goods upon them, taking it for granted that the Japanese, Americans, and Europeans had also received such things from their own ancestors. Thus an archaic culture whose core values were

grounded in ancestor worship tried to appropriate a mysterious prosperity by chasing after its icons.

Planes that didn't fly, radios made out of coconut shells, wooden weapons, straw telephones: all these surrogates were built in the attempt to bridge a huge technological, economic, and social gap. We sometimes talk about our own society's consumer fetishism, but cargo cults destroyed the metaphor by taking it literally until it became the only reality they knew, feeding off simulacra. The earliest documented case stretches back to 1885, while the most recent was in 1979 (the term cargo cult was introduced in 1945); but if we employ cargo cult to mean aspiring to consumer goods by passively imitating the outward appearances of modernity without first understanding its structure and how it works, then 21st century Venice would also make an interesting case study for contemporary anthropologists. Without analyzing the reasons for its decline, without trying to make up for lost ground by slowing the hemorrhaging of its inhabitants, and focusing on the right to the city and its citizens' right to work, many Venetians—including those in highly-placed governmental positions—have grown convinced that salvation will be delivered by cargo ship—gigantic vessels that flock to Venice, all the while polluting it, the passengers spending a few coins here and there; hypothetical skyscrapers for the superrich; vacation homes for those who already have too many of them; a subway system (to be called the *Sublagunare*) running under the Lagoon; and megalopolises throughout the Veneto. It is this mix of technology and stage sets which constitutes the essential ingredients for the simulacrum of a new reality to rapidly supplant the old.

The cargo cult practiced in Venice is contiguous, indeed identical, to a cult that enjoys far more followers: the venera-

tion of the absolute power of the market. According to Walter Benjamin, writing nearly one hundred years ago, capitalism has become a religion:

> It allays the same anxieties, torments and disturbances to which the so-called religions offered answers ... Capitalism is probably the first instance of a cult that creates guilt, not atonement ... A vast sense of guilt that is unable to find relief seizes on the cult, not to atone for this guilt, but to make it universal, to hammer it into the conscious mind ... The cult is celebrated before an unmatured deity.

This deity doesn't guarantee salvation, but does demand sacrifices. Thus the followers of the Venetian cargo cult never stop for a moment to think, they don't take into account the inordinately high costs that selling off their city—and thus giving up the monopoly on itself—will incur and what meager benefits they will receive in return. They assume that the deterioration of their city and the hemorrhaging of its inhabitants is an unstoppable force, and that they need to grab hold of whatever remedy they can, as though grasping for a life raft, even if it means squandering their city's enormous civic capital, as well as its beauty, history, and incomparable lifestyle. Tourism is a filter between the Venice that was and the Venice of today. The flow of visitors is used to legitimize any act of infamy, as though the city had been built over the course of centuries exclusively for tourists rather than for its own citizenry. As if anyone who visits Venice must experience it as though they were on a movie set without first having some appreciation for its inhabitants' customs and

extraordinary urban culture. Let's see what Nietzsche had to say in 1885:

> We can still see in the lower classes of Italians that aristocratic self-sufficiency, manly discipline and self-confidence still form a part of the long history of their country: these are virtues which once manifested themselves before their eyes. A poor Venetian gondolier makes a far better figure than a Privy Councillor from Berlin, and is even a better man in the end.

The hit-and-run tourism now afflicting Venice is both passively and archaically being mistaken for a gift from the heavens or the cargo gods, something which is worth emptying out the city for, forcing Venetians to abandon their ancient dignity and turning them into beggars. The threat of irresponsible architectural projects and insane urban proposals hangs over the city; yet the skyscraper ships that pass by Venice constantly proclaim that Venice isn't forever young and yet still perfectly formed, but is instead old, moribund, and poor, and must stretch its hand out to tourists and ask for alms.

In fact, one of those aforementioned projects, while still purely theoretical for now, is the ring of skyscrapers, but also the menacing shadow of the Palais Lumière, which as we discussed earlier on triggered a tough battle over the past few years and has been sidelined, but perhaps only provisionally. It's worth revisiting it, not only because this project may be resurrected at some stage (case in point, a July 7, 2014, article in the newspaper *La Nuova Venezia* argued that there wouldn't be any obstacles to it) but because something similar will eventually burst upon the scene. The Palais Lumière

project was hatched by Pierre Cardin, or rather by some architects associated with him, including a nephew of his who had only just received a university degree. Mindful of his origins from the mainland Veneto, the ninety-year-old Franco-Italian designer wanted to leave his mark on the Lagoon by building an enormous 820-foot-high skyscraper that would cost 1.5 billion euros and cover an area of forty-three acres in Marghera's dilapidated industrial zone. Its three intersecting towers would contain sixty floors of residential apartments, a "fashion university," as well as offices, shops, hotels, convention centers, restaurants, malls, and sports facilities. A vertical city pitched as a unique opportunity to revitalize an ailing industrial area. Yet Cardin's Tower of Babel would be 492 feet taller than St. Mark's Campanile, and soaring above Marghera, would inevitably dominate Venice's skyline too, defying every zoning regulation there is; and the only reason the Palais Lumière deserves its name is because it would be very bright and visible from every corner of the city, even at night. There's more: it would stand right in the path of incoming planes and breach the limit of 360 feet set by the aviation authority. Faced with various difficulties and criticisms, Cardin didn't seek only the help of ministers and highly-placed officials in city hall and the Veneto region, but furthermore declared that if his project wasn't approved, he would build an identical structure in China. A very telling threat of course, evidence enough that the project wasn't designed with Venice and its lagoon in mind, since it could just as easily be erected in China anyway. Thus, as far as Cardin is concerned, Venice is already identical to Chongqing.

It seems that a former mayor of Venice had the following to say when a journalist asked his opinion on the project: "It's horrible, but you don't look a gift horse in the mouth." Just how self-serving this gift really was, was evident from the adver-

tisements for the sale of apartments in Cardin's Palais: they
showed the huge bulky building in the foreground next to the
Lagoon with a nondescript dark spot in the distance. That dark
spot in the distance is none other than Venice, which, as in the
Aqualta Project 2060, is a panorama to be glimpsed from afar,
whose only function is to raise the cost of each apartment sold.
A real issue facing all Venetians, the regeneration of the for-
mer industrial zone of Marghera, has been hijacked to justify
real estate speculation. As part of the bargain, a new highway
planned in the vicinity would modernize Venice by making it
look like a Chinese or American metropolis.

Rethinking transit connections in order to save Venice
from isolation: this is yet another favorite theme of the high
priests of the cargo cult. The Futurists thought they could fill
the Grand Canal and pave it over, while their heirs today are
planning a huge metropolitan area that would turn the cit-
ies of Venice, Padua, and Treviso into a single megalopolis.
According to official promotional material:

> The integration of Venice's old town center
> within Veneto's metropolitan transport system,
> through the building of the necessary subla-
> gunar lines, would overcome the limits typical
> of water transport, as well as reduce the wave
> motion of the lagoon in the city, provide an ef-
> ficient transport system even with unfavorable
> weather conditions, and, most of all, it would
> avoid the physical isolation of Venice, thus pre-
> venting the crisis of economic activities and the
> consequent degradation of the social condi-
> tions on the Venetian archipelago.

And just to demonstrate how the market will save Venice, the Veneto City project is already underway: an enormous shopping mall, office complex, and transportation hub next to the Dolo-Venice Highway, which would swallow up the last remaining farmland in the area. Seventy-three million square feet of new buildings over 185 acres, new roads and highways, involving a 2 billion euro investment: all this at the expense of agriculture, which has been practiced around Venice since Roman times (the traces of which will be destroyed), to say nothing of the 16th century villas and historical parks in the region. This is where Veneto City, subsequently renamed Veneto Green City in a nod to ecologists, promises an "innovative model for a new city" which eventually intends to expand to 21 million square feet: a ghost town with no permanent inhabitants, but with leisure activities of all sorts (of course the designers couldn't fail to make plans for a contemporary art museum, even though they had no specific exhibition program in mind).

Needless to say, none of this is enough: plans have also been hatched for Tessera City in the vicinity of the Venice airport, being billed as the mainland entry to the city which naturally has been given an English name: Venice Gateway. God knows why this should require 7.1 million square feet of new buildings on ninety-five acres of land. Designed with Venice's bid to host the 2020 Olympics in mind, a bid which was luckily shelved, the project also included plans for an eighty thousand-seat stadium, with enormous sports and lodging facilities, shopping malls, and of course a starchitect to redesign the airport dock area: Frank Gehry.

Veniceland, Veneto City, Tessera City, Venice Gateway: aside from the rather provincial—and mimetic—use of the English language, these nefarious projects tell us that the old

Venice will no longer suffice. It must be forced into an unfet-
tered modernity made up of skyscrapers, office buildings,
highways, sublagunar transit lines, knockoff Disneylands,
huge shopping malls, and theme parks. To put it in a nutshell:
a vast urban area where "real life" involving the production
and consumption of goods will unfold, while the old Venice
will be relegated to an amusement park reached by high-speed
trains. A slow, merciless agony.

Throughout this never-ending succession of projects and
ideas copied from elsewhere, the Venetian cargo cult has both
its high priests and propagandists as well as its loyal worship-
ers, not to mention its victims. Those who loudly declaim
these notions and praise their merits are also those who buy
up land in order to sell it again at highly inflated prices so
that parts of the megalopolis can be built on them, or those
who pocket public funds through favorable bids and under-
handed financing methods, those who distribute and collect
percentages, kickbacks, and bribes to build what they call
great public works. Meanwhile, the cargo cult's loyal worship-
ers themselves become its prey: naïve citizens whom political
operators and the wielders of power and money have induced
to practice the rituals, convincing them that there is no alter-
native. Thus, Venice's real problems have become a pretext to
aggravate those problems even further, using the techniques of
a predatory economy.

There is no better proof of all this than the daily incursions
of gargantuan skyscraper-ships, which have colonized the
city while simultaneously wrecking it, veritable spaceships of
modernity, temples of consumerism which have annihilated
Venice's skyline. Like the colossal hotels of Las Vegas, these
ships with their thousands of suites have been passed off as an

exclusive luxury, yet they are nothing more than cookie-cutter machines that produce standardized pleasures. They peddle illusions and portray the blandest sort of mass tourism as a highly personalized experience. Ephemeral sanctuaries of a fanatical cult, these large ships have done everything possible to resemble new cities which have been reduced to the size of a skyscraper, replete with shopping malls, restaurants, dance clubs, cinemas, swimming pools, fitness centers, movie and dramatic theaters, casinos, ice rinks, and jogging tracks. They burst into Venice and yet they are themselves works of architecture. In a famous illustration from his 1923 book *Vers une architecture*, Le Corbusier placed several architectural monuments like Notre Dame, the Arc de Triomphe, or the Opéra next to the ocean liner *Aquitania* (which had room for 3,600 passengers) to compare them in size.

The greatest glory these monster-ships ever experience is when they parade their pompous arrogance and trespass into St. Mark's Basin, defying with their tacky bulkiness the ancient basilica, the Doge's Palace, and the horses stolen from Byzantium. Far taller than the noble houses flanking the Grand Canal, the ships penetrate Venice's heart to admire its beauty, but they cast a shadow over it and offend that very beauty, changing how it is perceived even for those on the ground, or in a gondola, or a *vaporetto* water bus. For instance, the *Voyager of the Seas* is 207 feet high, 1020 feet long, 154 feet wide, and features 47 levels; *The Costa Favolosa*, which is slightly smaller, competes with Las Vegas by offering replicas of the Imperial Palace in Beijing, the Circus Maximus in Rome, and a redux Versailles. *The Divine* is 220 feet high, twice as tall as the Doge's Palace, and 1092 feet wide, (or twice the breadth of Piazza San Marco). Meanwhile, centuries-old balances have been upset in the process by deepening the harbor mouths

to allow these ships in: Malamocco went from 30 to 56 feet, while the Lido went from 23 to 39. Curiously enough, those who defend these tourist necessities are the very same people proposing the sublagunar transit system whose aim is to reduce maritime traffic by reducing wave motion. They object to gondolas shifting a little water around but then promote the endless coming and going of cruise ships. Thirteen ships went by San Marco in a single day on September 22, 2013.

A series of appeals against the cruise ships has been of no avail including one from the Institut de France, while the Istituto Veneto has bestowed praise on the harsh articles written on this subject by Fiona Ehlers in the German weekly *Der Spiegel* on February 21, 2011, and one by Anna Somers Cocks in *The New York Review of Books* on June 20, 2013, entitled "The Coming Death of Venice?" Equally unheard was the appeal launched by the preservationist group Italia Nostra, echoed by UNESCO, and which protested these actions for damaging the city's unique form as well as its civic life. It gets worse. After the tragic and ridiculous shipwreck of the *Costa Concordia* on January 13, 2012, which left thirty-two people dead in waters off Tuscany, there was a heated debate both in the public sphere and in the government of then Prime Minister Mario Monti which led to stern legislation stating that ships should stay at least two nautical miles (2.3 miles) away from shore, especially on so-called salute maneuvers when a ship steers close to the coast in honor of someone or something. If applied to Venice, this decree would have heralded the end of the cruise ship era, but the government instead chose to do the opposite and stated that the law would be applicable everywhere except Venice. No succeeding government has addressed this loophole, not even after the serious incident on May 7, 2013, in Genoa when the *Jolly Nero* crashed into

the docks, killing nine people. According to those who govern us, Venice is therefore an exception, not because it deserves to be better protected, as the rest of the world expects it to be, but because it isn't protected at all. In fact, an incident similar to the *Costa Concordia* catastrophe almost occurred several times in Venice, like on June 23, 2011, when the German ship *Mona Lisa*—which is "only" 656 feet long—ran aground due to human error just a few yards from the Riva degli Schiavoni, and like on July 27, 2013, when the *Carnival Sunshine* scraped past the Riva Sette Martiri.

Every day enormous ships brush past the Doge's Palace, staring the city down, polluting its waters, outraging Venice and its people. Ministers, mayors, and port authorities tolerate this ruination (indeed they are complicit in it) all in the name of a single reward: money. Thus the noisy hubbub of "magnificent" and "fabulous" ships continues unabated while harming the most fragile and precious city in the world. Every year, a million and a half tourists descend on Venice briefly to give it a fleeting look from above, then buy a few trinkets from the stalls while munching on a sandwich (all of which, according to journalist Gian Antonio Stella, generates 270 million euros in profit, but causes 320 million in damages). With all these benefits, I suppose it doesn't really matter if Venice dies. As for the visual impact of those ships—amply documented by Gianni Berengo Gardin's photo exhibition entitled *Monsters in Venice* and supported by the *Fondo Ambiente Italiano*, which seeks to safeguard Italy's artistic and natural heritage— this has been exacerbated by increased turbidity, but also the heightened risk of collisions and the spilling of oil into the heart of the city, dangers that rise apace with the number of megaships admitted into Venice's waters each year (roughly 1,300). Nobody in the Ministry of the Environment or the

Prime Minister's office has bothered to calculate the impact of the pressure of thousands of tons of water on Venice's fragile shores. Nobody has offered any official data on the pollution caused by fine particles (five hundred tons in 2010), or commented on the presence of highly toxic benzopyrene in the Lagoon's waters. Nobody can say if the incidence of cancer has spiked over the past few years, although oncologists in Venice have in the meanwhile recorded a "significant excess of pulmonary neoplasms." (This was discussed by Silvio Testa in his pamphlet, *E le chiamano navi* (And They Call Them Ships), published in the praiseworthy series, *Occhi aperti su Venezia* (Eye on Venice), while other data are available in Tattara's *Contare il crocerismo* (Quantifying Cruising), which I cited earlier.)

Humiliating both the city and the rest of us, these ships have injected a variant of the fatuous rhetoric of skyscrapers into the very heart of Venice, and yet we can't even measure the gravity of this offense, nor have we understood that the ancient and yet perennially young poetics of the Venetian Lagoon could be far more promising if we stopped thinking of it as just an heirloom from the past, and instead saw it as a starting point for a promising future. Every day one can hear the same old refrain that the cruise ships will save Venice and its port, and every day more and more local inhabitants flee the city while real estate speculation makes it impossible for the young and the middle class to find any kind of work outside the tourist industry. Every day, thousands of people shut their eyes to avoid seeing or thinking. They are the pious, oblivious worshipers of a grotesque cargo cult that is both out of place and out of scale, yielding to the rhetoric that Venice has lagged behind the rest of the world and that it therefore needs to become worthy of the 21st century—and entry to this century will be enabled by construction companies, gigantic cruise

ships, and amazing technologies (like the MOSE project, an acronym for Experimental Electromechanical Module, which aims to protect Venice from flooding), while awaiting its final metamorphosis into a megalopolis of the future. Venice has finally become like Chongqing, except that while Chongqing has built a fake San Gimignano on its outskirts, the theme park within Venice proper is all ready to go: in fact, it's the historic city itself, which might eventually feature its own *Veniceland* right next to it. In this scenario, Venice's haggard survivors, who for the most part have been exiled to the suburbs on the mainland, might occasionally head over to Piazza San Marco on the sublagunar subway, while the city's real owners, the hordes of tourists, will arrive on their skyscraper-ships.

Even the so-called solution announced by the government on August 8, 2014, is neither satisfying nor definitive. While it's certainly true that the number of ships allowed to enter the Lagoon has been lowered—to two a day—all eyes are now on the planned canal of Contorta Sant'Angelo, which would be almost three miles long, and whose depth would increase from its current 20 feet to over 320 in order to connect the Canale dei Petroli to the cruise terminal. Among the various options that were considered, the government chose to side with the ship owners, without taking into account the vast environmental damage it might incur: the current 17 million square feet of sludge which need to be disposed of will rise to 43 million, which the Port Authority claims will force the need for new salt marshes and mudflat habitats. According to recent news reports, the Ministry of the Environment has already assessed the environmental damage and dropped the project altogether as a result, but a subsequent agreement mentioned a new evaluation of the impact. In any case, this decision makes clear that, in the words of Luigi D'Alpaos, one

of the leading hydraulic experts who has studied the issue, "We haven't learned the lesson the Lagoon taught us."

One always hears the same tired laments—"But Venice is fragile," "But Venice is old"—and meanwhile it is repeatedly assaulted with impunity. The fragility of Venice and its lagoon has triggered projects such as MOSE or Aqualta 2060, but this has also had its effects on a smaller scale. Commissioning a famous architect might seem like a good idea, but Santiago Calatrava has laid a bridge across the Grand Canal that was neither well thought out nor bore any stylistic resemblance to its site linking the train station with Piazzale Roma: a signature bridge that wouldn't look out of place in Brasilia or Shanghai. Yet Venice isn't just like any other city: regardless of whether one thinks it ugly or beautiful, the bridge that opened in 2008 is unsuited to the city, to the point that the Court of Audit demanded 3.4 million euros in damages from the project planners: "given that the bridge suffers from a chronic pathology that requires the need to constantly monitor it and continually make repairs that lie beyond ordinary maintenance work."

The fragility of Venice is a double-edged sword: considered to be an annoying ball and chain, the city can be ignored in the name of rapid modernization, but this will come at a high price. In order to build Calatrava's bridge, it was necessary to concede a building license for a nearby plot, which led to the construction of a fairly mundane hotel. Venice's fragility has been constantly proclaimed in order to launch various projects which actually worsen its situation, simply because they haven't been designed in concert with the highly delicate network of equilibriums that are centuries-old and which comprised the Lagoon and the forms of life that it still supports. To build in Venice without taking the trouble to understand and respect

these equilibriums is tantamount to mortally wounding the city.

An even more dangerous weapon used against Venice is the recurrent accusation that it is too old, unsuited to the modern world, or lagging behind other cities, needing various interventions to update it. This refurbishment has taken various guises: for instance, Benetton's project to modernize a famous historic palazzo, the Fondaco dei Tedeschi completed in 1508, involved installing panoramic terraces with views over the Rialto Bridge, as well as escalators in the courtyard, which were indispensable, or so it was claimed, to the palace's commercial viability. It's a shame that even a great architect like Rem Koolhaas yielded to the demands of a client that didn't take the city's historic value into account; furthermore, it was fairly bizarre that all this should take place at the same time that the Benetton Foundation in Treviso was sponsoring projects that aimed to protect the landscapes of the Veneto and promote awareness of the safeguards in Article 9 in the Italian Constitution. Let's face it. If such a project were ever implemented again amid the current climate of general indifference, we might even soon see escalators and panoramic terraces installed in the Doge's Palace.

As classical philologist Filippomaria Pontani has noted, in recent years Venice has witnessed:

> the infamous destruction of the Lido, the public's grotesque approval of the Cardin Tower, the abuse of the historic Arsenale, the farcical back and forth around the renovation of the Fondaco ... the massive usage of land foreseen in the Venice Province's Territorial Plan, the ruthless over-development of the Tessera Quadrant [despite] the struggle to defend the city's heritage,

the free use of public spaces and democratic de-
cision-making ... which are often dismissed
as instances of rear-guard action motivated by
conservative or misoneistic attitudes, an at-
tempt to put a spoke in the wheel of progress
and the free market.

Yet what do all these instances—and devastating projects
such as Veneto City, Veniceland, or Aqualta 2060—have to
do with the uninterrupted flow of cruise ships? Quite sim-
ply, all of these schemes claimed to be saving Venice. Yet if
we really wish to allow tourists to access the city via the sea,
why must we do so via gigantic cruise ships that pollute and
insinuate themselves into the city like skyscrapers? Given the
huge amount of land at his disposal, why couldn't Cardin
have planned to build smaller towers that would still have the
same total surface area? Architect and urban planner Gianugo
Polesello's provocative proposal for sixteen towers in Mestre
during the early 1990s should have suggested that the latter
approach would be far more favorable.

Only one answer possibly makes sense: that regardless of
whether it's ships or skyscrapers, the abuse of Venice isn't just a
random consequence, but the primary aim of such projects. As
architectural historian Manfredo Tafuri said in a 1993 lecture:

Even in its current cadaverous state, Venice is
still an unbearable challenge to the world of
modernity. Venice only manages to make it-
self heard in a whisper, but this is still simply
unbearable to our technological world, in this
technological era ... in which Venice is being
assailed by hordes of tourists, but also by the

naked ambitions of architects who aren't wor-
thy of being called architects.

Venice, an intact historical city which has been protected
by its symbiosis with its lagoon for over a thousand years,
radically contradicts the model of urban development based
on the relentless densification of inhabitants and the contin-
ual verticalization of modern architecture. Thus, Venice must
be pierced through the heart by inserting cruise ships, the
icons of prosperity, amid its houses and canals, envisioning a
future Venice as a city of skyscrapers. In each case, it is seen
as essential to desecrate this glorious city which has proved so
annoying to the preachers of modernity in the same way that a
virgin might frustrate a Don Juan who thinks himself irresist-
ible. This overt profanation is highly charged with symbolism:
It is the affirmation of a rampant hypermodernity that wishes
to exact revenge on the past, humiliating Venice by looking
down on it from atop a cruise ship, or from panoramic terraces,
or from a skyscraper in Marghera, leaving Venice's inhabitants
to play a residual role: yearning for meager economic benefits
in recompense for accepting their own city's suicide, reducing
themselves to the passive worshipers of a cargo cult.

CHAPTER XVI

Venice and Manhattan

While a profound revolution in architecture and urbanism was unfolding in Europe and America at the beginning of the 20th century, Venice was often used as a measuring stick. Filippo Tommaso Marinetti was especially garrulous and assertive on the subject in Italy, starting with his famous manifesto, *Against Past-Loving Venice*, which was widely distributed in the Piazza San Marco in 1910:

> We renounce the old Venice, enfeebled and undone by centuries of worldly luxury, although we once loved it and possessed it in a great nostalgic dream.
>
> We renounce the Venice of foreigners, market for counterfeiting antiquarians, magnet for snobbery and universal imbecility, bed unsprung by caravans of lovers, jewelled bathtub for cosmopolitan courtesans, *cloaca maxima* of passéism.
>
> We want to cure and heal this putrefying city, magnificent sore from the past. We want to revive the Venetian people, decayed from its ancient glories, morphinized by a nauseous cowardice …

We want to prepare the birth of an industrial and military Venice that can dominate the Adriatic Sea, that great Italian lake …

Let us quickly fill the small, stinking canals with the rubble from the old, collapsing and leprous palaces.

Let us burn the gondolas, rocking chairs for cretins, and raise to the heavens the imposing geometry of metal bridges and factories plumed with smoke, to abolish the falling curves of the old architecture.

Let the reign of holy Electric Light finally come, to liberate Venice from its venal moonshine of furnished rooms.

Giovanni Papini said much the same in 1913:

Florence is put to shame by the fact that it … does not live off the honest earnings of its living citizens, but off the indecent and miserly exploitation of the genius of its ancestors and the curiosity of foreigners. Half of Florence lives off the backs of foreigners, and the other half lives off those who live off foreigners. We must have the courage to shout that we are living off the backs of the dead and of barbarians. We are the caretakers of morgues and the servants of exotic vagabonds.

Marinetti echoed these sentiments by calling Florence, Venice and Rome "the Festering Carbuncles of Our Peninsula," while Venice would be able to save itself only by being "bru-

tally rejuvenated by progress." Patrizio Ceccagnoli recently noted the double synchrony of the Anti-Venetian Manifesto of the Futurists with the first Italian translation of Ruskin's *The Stones of Venice* (which also appeared in 1910) and the heated debate that ensued in the wake of the reconstruction of St. Mark's Campanile, which collapsed in 1902 and was rebuilt in 1912, but not without strong dissenting voices being raised, for instance those of poets like Carducci or modernist architects like Otto Wagner. Yet one must bear a third synchrony in mind, Thomas Mann's 1912 novella *Death in Venice*, the supreme literary snapshot of "that most improbable of cities" where "the narrow streets were unpleasantly sultry" and one could smell "an odor like that of stagnant waters" that came coupled with the "putrid odor of the lagoon." At that time, Venice was already the decadent image of a moribund city, but it was also a battleground for divergent conceptions of both modernity and the historic city.

In an unpublished theatrical work entitled *Ricostruire l'Italia con architettura futurista Sant'Elia* / Rebuilding Italy with Sant'Elia's Futurist Architecture, Marinetti went even further, imagining a series of bombardments that would turn Venice into a heap of rubble, with fights between the *Spaziali*, or the supporters of destruction, and the *Velocisti*, who took it upon themselves to "rebuild Holy Venice just as it was in only ten days," not by making it new, but by making it old, with the "already patented worm-eating machine" and "the wonderful invention called the Passéfier, which can produce two centuries' worth of moss in just ten minutes." This grotesque saga of reconstruction makes it abundantly clear that the author's preferences lie with building a very new Venice according to Sant'Elia's architecture. Italy had to be rebuilt, modernized, the barbaric tourists banished, thereby transforming a graveyard

into the land of the living once again, transforming Italians from "caretakers of morgues" into the hardworking laborers of "smoke-crested factories."

Marinetti returned to his Venetian obsession in 1943 and 1944, just prior to his death. Having sought refuge in Venice after returning from the Russian front, at a time when Italy was being veritably devastated by actual bombs—although Venice was spared—Marinetti wrote his "aeronovel" entitled *Venezianella e Studentaccio* (literally: The Little Venetian Girl and the Foul Student), which was not published in Italy until 2013 and involved a love story between the two main protagonists. Here, the idea of building a New Venice transforms into a fantasy of building an enormous sculpture on the Riva degli Schiavoni: "an enlargement of the most characteristic palaces and churches that combines and intertwines them but using a variety of materials that metamorphosizes them, especially via the unexpected development of glass-blowing art."

The monstrous statue represents Venezianella, the nurse with whom Studentaccio is in love, but on a gigantic scale: her "kilometer-long skirt" is made of seven "pompous Basilicas of St. Mark" fashioned out of green crystal, while the "new, enlarged Doge's Palace, making up a torso over five hundred meters wide" was topped by a "bonnet composed of an enlarged Ca' d'Oro." In other words, Marinetti's New Venice is a skyscraper whose aesthetic redemption is accomplished on two different levels: it encompasses the decorative vocabulary of the historical Venice while simultaneously imitating the shapely form of the female protagonist, and as Studentaccio/Marinetti says, it is also imitating "your immensely enlarged sculpture, meaning the gorgeous, ideal Venice dressed in Venetian fashions, which you so truly resemble, just like you resemble San Marco, the Doge's Palace, the Ca' d'Oro."

Just like the skyscrapers in Mississauga, Ontario, dubbed the Marilyn Monroe Towers for their voluptuous shape, Marinetti's New Venice is also a woman, especially because it represents the extreme evolution of that city "which we loved and possessed only in a nostalgic dream."

Thus is Venice putrid and cursed, bombed and turned to ruins—or is it instead sublimated into an idol that entirely engulfs and enlarges all its most iconic buildings to the point that they become grotesque? There's a strong sense of continuity between Marinetti's visions of Venice, the same that runs between "the imposing geometry of the metallic bridges and the smoke-crested factories" and the equally grandiose female colossus that rises above the defunct city. The verticality of this new architecture, the "fatal destiny of heights" which Nietzsche prophesied, is the only future which Marinetti envisions for Venice. He didn't much care whether this amounted to a gargantuan smoke-crested factory or a mock patchwork of historical architecture.

During those very years, this wordy, declamatory futurism was both interwoven and in stark contrast with where skyscrapers were actually being built: Manhattan. This is what James M. Hewlett, the president of the Architectural League of New York, wrote in his 1921 book *New York: The Nation's Metropolis*:

> New York, in addition to being a lot of other things, is a Venice in the making, and all the ugly paraphernalia by means of which this making is slowly going forward, all the unlovely processes, physical and chemical, structural and commercial, must be recognized and expressed and by the light of poetic vision be made a part of its beauty and romance.

Manhattan's grid plan had already been established as early as 1807-11, when the city numbered only a few tens of thousands of inhabitants; however, it called for a geometric grid of streets (twelve avenues from north to south, and 155 streets from east to west) which intersected to form 2,028 blocks. Yet as the grid filled up with people, and taller and taller buildings supplanted the older, smaller ones, the debate over the quality of urban life, overcrowding, and congestion grew more heated. The most well-articulated proposal at the time came from Harvey W. Corbett, a professor at the Columbia University School of Architecture. In order to bring order to the transportation chaos in a city in the midst of tumultuous growth, in 1923 Corbett proposed restricting Manhattan's streets to automobile traffic, making it run smoother thanks to tunnels and subways, and further widening the roads at the expense of the existing buildings' ground floors. Meanwhile, pedestrian movement would be confined to the upper floors with a series of walkways and porches that would constitute a continuous network around individual buildings, where people would be able to go from building to building using special bridges, set aside as well for the exclusive use of pedestrians. This area would also accommodate various shops, restaurants, and so on:

> We see a city of sidewalks, arcaded within the
> building lines, and one story above the present
> street grade. We see bridges at all corners, the
> width of the arcades and with solid railings. We
> see the smaller parks of the city (of which we
> trust there will be many more than at present)
> raised to this same side-walk arcade level ... and
> the whole aspect becomes that of a very mod-

ernized Venice, a city of arcades, plazas and
bridges, with canals for streets, only the canals
will not be filled with real water but with free-
ly flowing motor traffic, the sun glistening on
the black tops of the cars and the buildings re-
flecting in this waving flood of rapidly rolling
vehicles.

From an architectural viewpoint, and in
regard to form, decoration and proportion, the
idea presents all the loveliness, and more, of
Venice. There is nothing incongruous about it,
nothing strange.

This is Corbett's vision of the cities of the future, which are
destined to become myriad reincarnations of the city on the
Lagoon. Every single one of Manhattan's 2028 blocks was lit-
erally conceived as though it had been an individual Venetian
island with a vast network of bridges connecting them all to
one another: a veritable urban archipelago. Even the debates
that took place in the following years referred to Venice's
example: there were projects for a "Bridge of Sighs" across 49th
Street, and for Venice's canals to become the template for Man-
hattan's roads, where the flow of automobiles would replace
the Lagoon's waters; even the plan for Rockefeller Center could
be conceived as three blocks linked together, as though they
were Venetian-style islands. As Koolhaas writes in his vision-
ary work, *Delirious New York*, Corbett's style revolved around
"metaphoric planning" which turned Manhattan into a "Vene-
tian system of solitudes."

This is an allusion to Nietzsche's famous aphorism: "A hun-
dred profound solitudes make up the city of Venice—that is its
magic. An image [*Bild*] for men of the future." Thus Venice is

an image, likeness, or model—the German word *Bild* encompasses all these meanings, among others. The visions of the future hatched in the late 19th and early 20th centuries linked Venice with skyscrapers, but didn't necessarily put them in competition against one another. Nothing quite captures the essence and quality of urban life like the encounter of a hundred solitudes, but because this took place in Manhattan, the metaphorical mediation of Venice was a necessary step. As far as Marinetti was concerned, Venice was the antithesis of modernity. Nietzsche instead thought it was the symbol of modernity, while for Corbett it was a model and source of inspiration.

Compared to Nietzsche's poetic and prophetic inspiration and Corbett's urbanistic visions, Marinetti and Papini's invectives seem petty and dated. Nevertheless, even in the midst of the violent bickering so typical of Italians, a question was raised that has yet to be addressed. Marinetti writes that it would be better to destroy Venice than to see it reduced to a mummified museum-city for the exclusive use of tourists, a process then in its infant stages, and which has now become far more visible. Better a city for the living, Papini adds, than a community of "caretakers of morgues" living off the backs of the dead. Yet whenever we speak of Venice and Florence as museum-cities, occasionally with pride, aren't we essentially agreeing with these taunts and slights? Have we not contemplated turning our most famous and most visited cities into service stations for a hit-and-run sort of tourism? Haven't we degraded the very idea of the city by turning its citizens into servants? The flawed insistence on tourism as the ultimate reason why we should preserve our cultural heritage and landscapes actually overlooks the only point worth considering: that these landscapes and cultural patrimonies don't belong to tourists, they belong to citizens. Indeed, as the Italian Constitution explicitly says, insofar as

they are the building blocks of our identity and history, these landscapes and cultural patrimonies are consubstantial to the right of citizenship. They aren't just the heirlooms of our past, but reservoirs of moral energy we'll need to build our future. Citizens—and not tourists—are the real lifeblood of the city, the custodians of its memory, and the architects of its future. A city composed of citizens who are both aware of their own identity as well as their own specific culture, are more hospitable, more interesting, and even more welcoming for the tourists. Cities composed of servants are far less friendly.

Is Venice a "festering carbuncle" of the past, or a prophecy and metaphor of the future? This is up to us: but if its entire life takes place only in the past, a Futurist destruction will become inevitable. The mere passive preservation of the city as a mummified tourist attraction, or a theme park of itself, paradoxically presages and hastens its death. That said, there's certainly no need to tear down its monuments and replace them with smoke-crested factories in order for the city to start living its own life again, and not just scrape a living off its past. The future of the historical city is a vast topic being played out not just in Venice or Italy, but in the rest of the world too, and Venice even as a prophetic vision of Manhattan can be taken as its supreme symbol. With each passing day it becomes increasingly urgent to ask oneself how every city can meld its symbolic capital with its citizens' civic capital and put this to fruitful use. If this should ever happen in Venice, it could happen everywhere else.

CHAPTER XVII

The Architect's Ethics:
Hippocrates and Vitruvius

Who's killing the historic city? Who's surrounding it with soulless suburbs, who's gutting ancient palaces to parcel out its land, who humiliates cathedrals with arrogant skyscrapers, who fights for housing policies that increase the height of apartment blocks by topping them with incongruous excrescences? Politicians, of course, as well as construction magnates, real estate speculators, and various manifestations of Mafia networks who invest their enormous capital in bricks and mortar. They are ordinary citizens, ready to seize any opportunity to pursue their own interests and line their pockets. Yet the list also includes architects, engineers, surveyors, and planners, who become either the authors or the henchmen of the looting of our historic cities and landscapes, sometimes out of ignorance, or cynicism, or greed, or simply because they are beholden to a company or a politician. It is because of them that suburbs are growing in an unregulated fashion, or that cities and swathes of countryside are being filled with a bullying sort of architecture that devastates cultural memory and undermines the future of our societies. And yet any criticism is silenced through the extortionate involvement of starchitects, various advertising gimmicks, or endless paeans to modernity, skyscrapers, and the purported

aesthetic qualities of every imaginable kind of real estate transaction.

The creativity of artist-architects is still loudly proclaimed even when it breaks the law or jeopardizes the fates of those who will live and work in these new buildings. As Robert Venturi wrote, "modern architecture has been anything but permissive: Architects have preferred to change the existing environment rather than enhance what is there." Yet architects who irreversibly denaturalize environments and contexts do so on behalf of third parties, selling their services for cash (customers) or favors (politicians). The aesthetic virtues of these architectural structures, praised by their own designers and sympathetic critics, actually mask the cynicism of the financial wheeling and dealing and real estate speculation that triggered them in the first place. This aesthetic legitimization removes the architect's responsibilities and serves as an alibi for his or her patrons: this is the phenomenon of professional camouflage that seeks to hide the speculative activities of great architects, as described by the late Italian architect Giancarlo De Carlo, who argued that the profession had a civic duty to question flawed practices.

Do architects really operate in an empyrean realm governed solely by aesthetics which bear no relationship to society, citizenship, and cultural memory? In fact, the opposite is true: the architect's craft has a palpable, widespread impact on everyone's lives through the changes it makes to urban environments and landscapes, meaning not only the foundations of people's daily lives, but also on the dynamics of civil society. We must therefore ask ourselves the following question: Is the architect's craft regulated by a code of professional ethics? Should an architect merely obey a customer's orders, or should they have a broader vision when they design and build a structure, or transform a city or a landscape? Should they configure

their designs according to the historical, environmental, and social contexts in which they are working, or should they pretty much disregard them completely? For instance, when planning a building in Venice, should an architect take its urban and historical context into account, or instead make it look like some extraterrestrial structure that fell out of the sky and could be at home in Venice, Chongqing, or Dubai?

In his introduction to the catalogue of the 2014 Venice Architecture Biennale, Rem Koolhaas truly grasped the urgency of the matter: "The market economy has eroded the moral status of architecture. It has divorced architects from the public and pushed them into the arms of the private sector—they do not serve 'you' any more, but a diffuse 'them.' It has been forced to move solely within the neoliberal system masterminded by Ronald Reagan."

As it happens, *Less Aesthetics, More Ethics* was the banner under which an earlier Biennale was held in 2000, but in the catalogue the curator Massimiliano Fuksas wrote that:

> It's not advisable to seek etymological or philological explanations for LA, ME ["Less Aesthetics, More Ethics"], nor to spend months debating whether the aesthetic contains the ethic or vice versa. I sincerely hope that nobody will think of taking up again Kant's three criticisms. The true answer lies in the approximately ninety installations of the Biennale. We have correctly identified the problem, and I believe that many of the works exhibited here provide the answers that we're seeking. Yet what we're talking about here is a laboratory of ideas, and it's far too soon to draw any conclusions. This exhibition is but

only the beginning of such a process, of an investment in our future.

As British architect Neil Leach noted, these are shifty, elusive words. In an essay he contributed to the edited volume *Architecture and its Ethical Dilemmas,* Leach said that the aestheticization of architecture leads to

> an elision of social, economic and political concerns that is brought about by an approach which could be accused of being a form of aestheticisation ... The aestheticization of the world induces a form of numbness. It reduces any notion of pain to the level of the seductive image. What is at risk in this process of aestheticization is that political and social content may be subsumed, absorbed and denied. The seduction of the image works against any underlying sense of social commitment. Architecture is potentially compromised within this aestheticized realm. Architects, it would seem, are particularly susceptible to an aesthetic which fetishizes the ephemeral image, the surface membrane. The world becomes aestheticized and anaesthetized. In the intoxicating world of the image, the aesthetics of architecture threaten to become the *an*aesthetics of architecture.

The aestheticization of architecture has killed ethics because it has been used to legitimize real estate speculation and has become a mere market mechanism, which turns a blind eye to morally pressing issues—our society, justice, the

right to the city—in the pursuit of profit. Nevertheless, as historian and critic Anthony Vidler writes: "There has never been a more propitious moment than now to revisit the question of architecture's social responsibilities ... The gap that exists now between the specialized discourses of planning, architecture, political process and the public has never been so great."

We won't find an answer in the works of philosophers and anthropologists, but in architects' own consciousness and in their professional practices. In recent years, the Italian architect Lina Bo Bardi, who graduated from architectural school in Rome in 1939 but then worked in Brazil from 1946 until her death in 1992, has become the symbol of this new awareness which is all the more necessary given how rare it is. Having resolved to fight in favor of a "collective conscience of architecture," where the architect's freedom is "first and foremost a social problem which must be examined by looking within political structures, and not outside of them," Lina Bo Bardi harshly criticized Oscar Niemeyer's aesthetic bent:

> Architecture can be suffocated by forms, by compositions, by the aura of monumental European squares ... Designers who look at architectural magazines sitting at their desks and don't have eyes for reality [meaning the communities which are destined to live in these buildings] will be the creators of abstract buildings and cities. Architects must prioritize not their formal individualism but their awareness of being useful to people through their art and experience ... This is the true meaning of architecture today. After all, isn't the modern architect, the builder of cities, neighborhoods

and houses an active soldier in the realm of so-
cial justice? Shouldn't an architect foster moral
doubts, gear his or her conscience toward hu-
man injustice, have an acute sense of collective
responsibility, and thus nurse a desire to fight
for benign, morally positive aims? ("arquitetura
ou Arquitetura," in *Crônicas de arte, de história,
de costume, de cultura da vida*, 1958).

As far as Bo Bardi was concerned, architecture dominated
by aesthetics had to give way to an Architecture with a capital
A, which would be informed by ethical, social, and political
concerns; thus, the architect's work has to be considered as a
civic duty which entails inescapable moral responsibilities. In
Bo Bardi's writings and buildings, "Architecture exerts a vivi-
fying and unifying effect, which is only possible when the need
for a better social life is genuinely important to the architect's
imagination," according to critic Martin Filler, writing in the
May 22, 2014 issue of *The New York Review of Books*.

The topic of professional codes of conduct and ethics is
not at the forefront of our day, given that we merely look at
the price tag of things. Moreover, this kind of thinking has
always been more pronounced in some professions rather
than others. The most elucidating example to be found is
probably that of physicians and their Hippocratic Oath. This
text was written around 400 BCE and occasionally attributed
to Hippocrates himself, while its success in our modern era
arguably began in the 1500s, was reenergized in the wake of
the French Revolution in 1789, then reaffirmed by the Decla-
ration of Geneva by the World Medical Association in 1948.
The oath is still used in various countries: for instance in the

United Kingdom, where the British Medical Association published a modernized version of the text. Various versions exist, not only in Greek, but in Latin and in all European languages; regardless, a few key points are commonly found in all these different texts, in particular the solemn oath sworn by physicians: "I will apply dietetic measures for the benefit of the sick according to my ability and judgment; I will keep them from harm and injustice ... Whatever houses I may visit, I will come for the benefit of the sick, remaining free of all intentional injustice, of all mischief."

It would be quite simple to adapt these tenets to the architect's profession via metaphors or analogies, given that the city and the landscape are the material embodiment of the social body. Yet one could attempt to go further by employing Vitruvius as a starting point, an architect who lived during Emperor Augustus's reign. He is less important today for what he actually built than for his treatise *De architectura*, a vast work comprising ten books which has exercised immense sway over the European tradition, at least since the time of Leon Battista Alberti, and of Daniele Barbaro's first Italian translation of this work in 1556, which featured illustrations by Andrea Palladio.

At the beginning of Book I, Vitruvius gives us a portrait of his ideal architect, and the most important qualities he should possess:

> 1. The architect should be equipped with knowledge of many branches of study and varied kinds of learning, for it is by his judgment that all work done by the other arts is put to test. This knowledge is the child of practice and theory. Practice is the continuous and regular exercise of employment where manual work is

done with any necessary material according to the design of a drawing. Theory, on the other hand, is the ability to demonstrate and explain the productions of dexterity on the principles of proportion.

2. It follows, therefore, that architects who have aimed at acquiring manual skill without scholarship have never been able to reach a position of authority to correspond to their pains, while those who relied only upon theories and scholarship were obviously hunting the shadow, not the substance. But those who have a thorough knowledge of both, like men armed at all points, have the sooner attained their object and carried authority with them.

3. In all matters, but particularly in architecture, there are these two points:—the thing signified, and that which gives it its significance. That which is signified is the subject of which we may be speaking; and that which gives significance is a demonstration on scientific principles. It appears, then, that one who professes himself an architect should be well versed in both directions. He ought, therefore, to be both naturally gifted and amenable to instruction. Neither natural ability without instruction nor instruction without natural ability can make the perfect architect. Let him be educated, skillful with the pencil, instructed in geometry, know much history, have followed the philosophers

with attention, understand music, have some
knowledge of medicine, know the opinions of
the jurists, and be acquainted with astronomy
and the theory of the heavens.

Vitruvius elucidates his reasons and motivations behind
each of the intellectual virtues and skills which his ideal archi-
tect must possess; for instance, he argues that "by means of
optics, again, the light in buildings can be drawn from fixed
quarters of the sky"—or that some education in medicine
would allow said architect to study climates and their effects
on people, ensuring that houses are built to be healthy, while
philosophy would teach him to be "courteous, just, and honest
without avariciousness. This is very important, for no work
can be rightly done without honesty and incorruptibility. Let
him not be grasping nor have his mind preoccupied with the
idea of receiving perquisites, but let him with dignity keep up
his position by cherishing a good reputation." Could a single
human being ever possibly acquire all these qualities? He cer-
tainly could, Vitruvius argues, since all fields of knowledge are
intimately interconnected, but only so long as the architect is
properly educated in all the disciplines required for his job.
The architect's work therefore depends on his education, and
whether he or she adhered to the ethics of their profession.

We could easily adopt every single one of the professional
requirements that Vitruvius lists in his book and compile
them into a "Vitruvian Oath," turning it into the perfect equiv-
alent of the Hippocratic Oath. If anyone who designs and
constructs buildings in Italy today had sworn that oath, they
wouldn't have dared to build so many houses close to the most
toxic dumps and landfills in the southern Campania region
of which Naples is a part, since they would know to "learn

whether sites are naturally unhealthy or healthy" and would thus feel morally compelled to build only "salubrious houses." If architects knew a little more about the law, they might start adhering to it more closely. If those who build in Venice knew how to marry practice and theory, no architectural design would so flagrantly ignore the physical conditions and construction practices unique to that city.

Any Vitruvian Oath would truly need to focus on that essential ingredient to the architect's education which Vitruvius himself considered of the utmost importance: history. Indeed, Vitruvius's ideal architect would know that "a wide knowledge of history is requisite." The average educational curriculum in his times did not feature a historical component, and thus when he refers to history, he is referring to the plural histories which an architect must be acquainted with. Yet does it really make sense for architects to know much about history these days? Or, better yet, which specific histories should he or she be acquainted with? The World Medical Association continues to update the Hippocratic Oath, for instance by removing the ban on abortion, in such a manner as to constantly reinforce its timely relevance. Astrology certainly isn't valuable any more. Yet is history itself deemed necessary for an architect these days? It's certainly becoming less so in architectural schools: it's almost as if the memory of our past were a burden to rid oneself of in order to live in a mindless present. The postmodern era has left us a cumbersome legacy: it has turned the architectural styles of the past into a rigid repertoire of options, a vocabulary of disparate elements from which we can draw lexical fragments at will and use them as references.

A reductive presentism has entrenched itself everywhere we look, even in architectural schools, which restricts and impoverishes our horizons (time) in the name of globalization

(space). T. S. Eliot predicted all of this in his 1944 essay "What Is a Classic?":

> In our age, when men seem more than ever prone to confuse wisdom with knowledge, and knowledge with information, and to try to solve problems of life in terms of engineering, there is coming into existence a new kind of provincialism which perhaps deserves a new name. It is a provincialism not of space, but of time; one for which history is merely the chronicle of human devices which have served their turn and been scrapped, one for which the world is the property solely of the living, a property in which the dead hold no shares. The menace of this kind of provincialism is, that we can all, all the peoples on the globe, be provincials together; and those who are not content to be provincials, can only become hermits.

"Presentism," a word that is specifically employed in France, is perhaps the name which Eliot foresaw for this new provincialism which has spread all over the world. Yet can the study of history serve as an antidote to this presentism? Would architects truly find it useful? According to an oft-abused saying, "History is the school of life." But let's try to turn that maxim on its head: Let us instead say that life is the teacher of history, as did the 20th century historian and classicist Gaetano De Sanctis. In fact, the urgency of the present prompts us to reexamine the events of the past not as a mere accumulation of data, or a dusty archive, but as the critical, living memory of human communities. This would be the

only way in which the past could become leavening for the present, a reservoir of energy and ideas that we could use to build our future. The architect doesn't professionally study history, but his or her profession is both empty and miserable without it, all because history, meaning the awareness of our collective cultural memory, is the foundation of the notion of responsibility. Conversely, anyone who places aesthetics above history is advocating a kind of architecture that is both socially irresponsible because it harms society and essentially servile because it is beholden to its customers.

The kind of history an architect needs doesn't just consist of Vitruvius, Palladio, or Wright. It must also include the history of the country and city where they intend to ply their trade. In Italy, architects should be aware that despite the fact that the preservation of our artistic heritage, historical sites, and landscapes are solidly constitutionally enshrined and framed within a complex set of regulations, recent history shows, as economist Federico Caffè pointed out, that there is a huge "gulf between legislative safeguards on paper and concrete, everyday practices." In Venice's case, no architect in their right mind could argue against the fact that the city is losing all its inhabitants and that it risks turning into a theme park dotted with second and third homes, hemorrhaging not only its people but also its creative energies, social life, and cultural wealth, humbly reducing itself to a movie set for impatient tourists to quickly wander through. Thus, no architect should ever agree to building anything—whether it's a bridge, a terrace, or a window—that might contribute to the death of the historic city by destroying its uniqueness.

No one who truly claims to defend Venice or other historic cities can force them into a state of mummification and keep them eternally the same, or worse, force them to live in a fake

paradise of nostalgia. Such a person should instead consider the city and its architectural works as the living embodiment of its citizens, the men and women who live in Venice, or who would like to live there, but are instead forced to flee it. Such a person should treasure the city's physical body as well as its soul, to think of both its material texture as well as the life-blood of its inhabitants; to consider architecture as an essential component of the right to the city, which also includes the crucial components of the right to work and the social functions of private property. Yet the right to the city must also allow room for the architect's creativity, and his or her ability to put historical spaces back into use or even enhance them with designs which conform to the city's DNA. If only because a Venice without any historic depth would never have inspired something like Manhattan.

Sir Isaiah Berlin used to love reciting the German aphorism *Menschen sind meine Landschaft*—People are my landscape—and it applies even more so to cities: a landscape *for* the citizens, *by* the citizens, and not just a Monopoly board for real estate speculation and rent collection. Architects must work to make cities and landscapes the mirror image of democracy, the living embodiments of the principles of civic life, the projection of our desire to live our present lives well, but also to enshrine the ethical imperative of leaving future generations an environment and network of cities worthy of what we ourselves inherited. We must ask architects to stipulate a new social contract, to swear an oath of loyalty to these principles, to develop a self-awareness that contributes to the narrative of civic life by correctly interpreting society's needs for fairness and justice. In Italy's case, such an architect would endorse the principles of the common good enshrined in the country's constitution.

There is nothing traditionalist and conservative about the idea of a Vitruvian Oath; in fact, quite the opposite is true: it is solidly grounded in the present and geared toward the future. For instance, Vitruvius's strong injunction that the architects of his time have some knowledge of medicine in order to ensure that they built healthy houses is echoed in the Italian Constitution, which "safeguards the natural landscape" (Article 9) and furthermore "safeguards health as a fundamental right of the individual and as a collective interest (Article 32)." Given the convergence of these articles, safeguarding the environment is a "primary and inalienable constitutional principle," in the words of Italy's Supreme Court, since it is in the interest of all Italian citizens. In keeping with the most advanced ecological values and with the struggles to uphold the right to the city and the public interest, this link between medicine and architecture is first and foremost grounded in ethics rather than aesthetics. Instead of building cities and landscapes we can *look at*, we must build cities and landscapes we can *live in*. The salubriousness recommended by Vitruvius, which is prescribed by the Italian Constitution, and which has been asserted by environmental movements worldwide, must ensure the health of both individuals and the community of citizens.

Fragile and precious, doomed according to some, deemed in need of modernization by others, today's Venice is a tangle of contradictions more than at any other time in its history. It could still become the ideal place to relaunch devotion to a healthy urban life and the right to the city, as well as the need for an architectural code of ethics. This would enable adoption of a Vitruvian Oath informed by the Hippocratic Oath, the Italian Constitution, and in strong accord with the global movement to uphold the right to the city.

CHAPTER XVIII

Venice: A Thinking Machine

"Ghetto" was a Venetian word that was eventually used all over the world. It originally meant "foundry" and this was the spot where the Jews were settled in 1516 once all the activities related to the foundry were relocated to the Arsenale. In his admirable essay *The Foreigner*, sociologist Richard Sennett writes:

> The formation of the Jewish ghetto in Renaissance Venice suggests a more complicated story … The experience of Jews in the Venetian ghetto traced an enduring way of tying culture and political rights together … segregation was made into a positive human value, as though the segregated had been kept from contagion … The sanctity of verbal contract established a connection between economic rights and the rights of free speech.

In what was then "the most international city of the Renaissance," or better yet, the "first 'global city' of the modern world," the community of the ghetto grew "to think of society as a collective body" and "forms of collective representation" that hinged on an awareness of its rights. Sennett believes that the paradox of Venice's urban shape (a community of people

who were excluded and yet nevertheless developed a strong sense of self-awareness) is the key to understanding the formation of "social practices that transcended legal formulations and the state's hegemony" where "the sanctity of verbal contract established a connection between economic rights and the rights of free speech." Freedom of speech tends to neatly coincide with the right to the city.

These days, a blind presentism under the yoke of the market marginalizes every kind of dissent by relegating it to new ghettos. For example, the one inhabited by the Venetians who have clung to the historic center of their city and who are defending it from the monoculture of tourism and from the fashions of a self-indulgent architecture; or the one inhabited by people both in Venice and the rest of the world who are laying claim to the wide variety of models of urban living, and the quality of the historical *forma urbis*. This minority status, which belongs to the segregated who have "been kept from contagion," can actually become a source of great strength. But it will become so only if the embattled citadel of the few manages to acquire enough self-awareness, develop planning skills and forms of social solidarity, and exercise the right to free speech. The practices developed by citizens associations, claiming the right to the city (on a global scale), the awareness of the high-minded goals of the Italian Constitution (for those within Italy), the awareness of Venice's local issues, and the widespread diffusion of information, a capacity for debate, the link between the economic rights of citizens (as individuals and as a community) and the civic capital accumulated over the course of great spans of time: these are the concepts which will make it possible to create community spaces and forge a renewed self-consciousness so that cities will have a body *and* a soul, both in Venice and elsewhere.

Venice is the paradigm of the historical city, but also of the modern city like Manhattan. It's a thinking machine that allows us to ponder the very idea of the city, citizenship practices, urban life as sediments of history, as the experience of the here and now, as well as a project for a possible future. Its problems are complex in an unparalleled way due to its relationship to its surrounding environment and the huge disproportion between the supreme importance of the historical city and the government's chronic incompetence, and finally due to the demographic, cultural, and economic decline currently afflicting it. However, to look at Venice and think only of Venice would be to miss the point entirely: the processes currently under way in that city, like the degradation of the historic city center and its loss of inhabitants, the rhetoric of a standardized modernity, and the blind pursuit of profit, can be found everywhere else on the planet. Like a critically ill patient, Venice's wounds, more visible there than elsewhere, are proof of a widespread disease; and just like a celebrity patient, it attracts more attention than any other city in the world. Thus, whatever happens in Venice requires special scrutiny as both an indication and a laboratory of what fate has in store for the cities of the future.

Venice is the supreme example of a deeply disturbed balance between the center and the periphery, between nature and culture (between the city and the lagoon); but also of the greed and corruption that uses the city's problems to turn a profit. The terrible flood of 1966 underlined its fragility in the face of tides and rising waters; thus, the idea of protecting it with a system of movable barriers situated at the mouths of harbors was hatched in 1976: the MOSE project. Then billed as a triumph of technology, this great public work grew old before it was even born, yet time has made only more clear the per-

verse relationship between the political establishment and construction companies. "It will definitely be operational by 1995," Italy's then Prime Minister Bettino Craxi announced in 1986. Yet by early 2016, work had still not been entirely completed. Meanwhile, politicians have brushed aside not only the doubts expressed by various experts and institutions, but also the 1998 negative findings of an official environmental impact study. Now we all know why, thanks to the recent revelations of the widespread corruption surrounding the scheme and the waste of public resources triggered by MOSE. The investigations have led to the indictment and/or implication of the former Venice mayor, Giorgio Orsoni, a former governor of the Veneto region, Giancarlo Galan, the former head of the Water Authority, as well as officials at the Court of Audit, the New Venice Consortium, the company awarded a monopoly on all work carried out on MOSE, and a host of other public officials, institutions, and businesses. In short, MOSE was:

> more beneficial to the companies which were awarded monopolies to build it, and by the politicians who used it for illicit gains, than to the Venetian citizens for whom it was supposedly designed … In the meanwhile, MOSE swallowed up 6.2 billion euros worth of public funding, or a third of the 18.7 billion spent to protect the city since 1984, to which an additional 1.5 billion should be added to account for maintenance costs. The whole thing should have cost less than 2 billion … We have estimated that the cost of awarding a monopoly to build MOSE amounted to over 2 billion.

Economist Francesco Giavazzi and journalist Giorgio
Barbieri, to whom we owe the above words from their impec-
cably written and researched 2014 book, *Corruzione a norma
di legge. La Lobby delle grandi opere che affonda l'Italia* (Legal
Corruption: How the Lobbyists of Great Public Works are
Bankrupting Italy), also argue that corruption and criminal
actions do not solely account for what happened: "The break-
ing of laws and the incidence of corruption are not mutually
exclusive." In fact, "the laws were specifically bent and broken
to line the pocket of construction companies and politicians."
In "the absence of any realistic consideration of the fragility of
the surrounding environment," the pact forged between public
servants and construction companies pursued a "single aim,
that of maximizing the profits that could be earned from sell-
ing Venice's name." The cost/benefit ratio, which was favorable
at first, has now been turned on its head, and the costs of the
MOSE project far outweighed its advantages. The sheer scale
of this corruption prompted Prime Minister Matteo Renzi's
government to shut down the Water Authority in June 2014,
thus bringing its five hundred-year history to an end after it
had outlasted the end of La Serenissima, Austro-Hungarian
rule, and the various regimes that followed Italian unification.

Nonetheless, those who want to keep milking this cash
cow have already lined up to secure the lucrative maintenance
contracts for the upkeep of the MOSE barriers once they
become operational, as well as lined up yet another "great pub-
lic work" worth 2.8 billion euros: Venice's offshore port. Right
at the top of that list are the same companies involved in the
MOSE project in the first place, and the same clique of bipar-
tisan bedfellows: "The offshore port will be a catalyst for the
city's development," Renato Brunetta, a parliamentarian rep-
resenting Forza Italia, a center-right party, has stated. "Venice

cannot give up on development, it must extricate itself from the trap of conservationism," added another parliamentarian, Pier Paolo Baretta of the Partito Democratico, a center-left party. The project website states:

> The offshore platform will be protected by a 4.2 km. long breakwater dam which will shelter an oil terminal and a container terminal able to accommodate up to three latest generation container ships at the same time ... The entire project—consisting of the onshore terminal and the offshore platform—was approved by the Higher Council of Public Works (by its special section overlooking any project dealing with the safeguarding of Venice and its Lagoon).

"Extricating itself from the trap of conservationism" therefore means abusing a law that is meant to safeguard the city and its environment in order to "tear everything up and gut it, digging rectilinear canals, building cement banks and warehouses," says the preservationist group *Italia Nostra*. But the MOSE affair demonstrates that Venice's problems have been used as a pretext to invoke empty rhetorical formulas of preservation, while actually allowing private interests to rob the city blind. These private interests of course are involved in several great public works, so much so that according to Giavazzi and Barbieri "the magistrature's investigations into [the Milan] Expo 2015 revealed the involvement of the same companies behind the MOSE project."

Venice is therefore a textbook case of public corruption. All over the world, and not just in Venice, historic cities are being emptied out while its institutions give priority to tour-

ist monocultures and hikes in real estate prices, unleashing a form of ethnic cleansing that is banishing the young and poor from their cities. All over the world, and not just in Venice, "the aesthetic ambitions of architects not worth the name," as architectural historian Manfredo Tafuri put it, are chasing a quick buck by building bloated suburbs, taking on any commission whatsoever even at the cost of tearing apart historic centers, and slavishly adhering to the rhetoric of skyscrapers. All over the world, and not just in Venice, communities of citizens have woken up to find themselves strangers in their own homes, because both the city and its land have been used as a hunting ground or a bank to rob. All over the world, and not just in Venice, all sorts of creative jobs are disappearing, leaving "lost generations" of young people who are then forced to emigrate, depleting civic consciousness and dismissing the right to the city. More than any other historic city of its kind, Venice "is an unbearable threat to the world of modernity" (Tafuri); and this is exactly why it has become a victim of that modernity, which has treated the city like a lab rat to be vivisected and stripped to the bone in order to perform daring experiments, as architectural theorist Teresa Stoppani discusses in her 2011 book *Paradigm Islands: Manhattan and Venice*. Yet deconstructing Venice on a conceptual level into a city of fluid and ahistorical shapes that should be examined in the light of a presentist aesthetic is the first step toward physically deconstructing it (i.e., destroying it). The architect must therefore commit himself or herself to do the exact opposite: to never think of the shape of the city without first considering its lifestyle, job opportunities, and the future of its citizens. This is why thinking about Venice also means thinking about historic cities, or indeed any city.

Thinking about the city isn't a mere intellectual exercise,

it also aids our political and democratic understanding; it requires a knowledge of the present, but one that also keeps an eye on both the past and the future. Today's city is:

> an intricate, flowing map which is to be used as a starting point for an understanding, first, of how a city is made, and, second, of how it can be re-made … The more negative the image we have today, the more we'll need to gear ourselves toward a more positive image … without losing sight of the one element of continuity that the city has perpetuated throughout its entire history, that which set it apart from other cities and gave it meaning. Every city possesses its own specific "plan" which it must recover every time it loses sight of it, unless it wishes to become extinct. The ancients embodied the spirit of the city by invoking the names of the gods associated with its founding … names that were the personification of vital attributes of human behavior or the elements (a river, a specific kind of land, various types of vegetation) which had to ensure its survival throughout all its successive transformations, as an aesthetic form but also as a symbol of an ideal society. A city can weather many catastrophes and dark ages, but it must find its gods again at the right moment in order to do so (Italo Calvino, "The Gods of the City," 1975).

Venice's gods are far more demanding than those of other cities, because throughout its history its inhabitants were more varied and productive than those elsewhere, and because the

city has faced a more difficult challenge from its surrounding environment. This precious, unique, and difficult city—difficult due to its singular relationship to the Lagoon and the mainland, bucking the trend affecting other cities because it is naturally pedestrian-friendly and devoid of cars—is the ultimate symbol of a city built on a human scale. It both challenges us and asks us the following question: Should we preserve this unique way of dealing with space, or should we abandon it by forcing it to adhere to a lone model that will produce identical cities all over the world?

There's nothing more mainstream and politically correct than praising diversity. Diversity of gender, sexual orientation, religion, culture ... yet although this diversity is highly prized on an individual level, it doesn't apply to cities, which are now under the yoke of a rampant homogenization. The living embodiment of the historic city and its lifestyle, Venice is the litmus test of the process of dissolving the ancient forma urbis, now reduced to a remnant of its former self. Even the fact that the city is losing its inhabitants, a process hastened by the very institutions set up to prevent it, has an undeclared yet obvious aim: to erase its diversity, reducing public spaces to tourist movie sets. Saving the historic city in Venice (and elsewhere) won't happen simply by reviving memories of the city's past or indulging in the pleasures of the present. Even protesting won't be enough: the only effective move will be reenergizing the active practice of citizenship and exercising the right to the city, to then come up with a plan to preserve its uniqueness and put firm rules into place that not only safeguard its framework and environment, but also prioritize the city's use-value over its exchange-value, emphasizing the social function of property, the right of its citizens to gainful employment, and the right of its youngest to both a home and a future.

A city with a long history of cosmopolitanism, Venice can still be a testing ground for an inclusive notion of citizenship relevant to our times. If the city is a producer of social and cultural space, a theater for thought and rights, a laboratory of the future, then it has become more important than ever to understand the practices of citizenship vis-à-vis the new Italians who have come from other parts of Europe or other continents and are now becoming part of our society's social fabric. Their growing numbers and demographic importance make them crucial players in the cities of the future. None of our heritage and landscapes will survive unless they are made aware of its worth, if schools and communities aren't able to impart the spirit of the city to those who inhabit its body. The deceptive cosmopolitanism of the hordes of tourists flocking to Venice won't help expand the horizons of this notion of citizenship, to push beyond the basic notions of *Jus soli* or *Jus sanguinis*—a notion of citizenship rooted in one's place of birth, or blood—and instead settle on *Jus voluntatis*, to borrow a term from the writer and activist Michela Murgia, or in other words, the willful desire to be citizens. In his *Crito*, Socrates says that citizenship is a pact between the citizen and his or her homeland, which implies a conscious choice and entails certain responsibilities. Those who choose to remain in the polis (in the community) must abide by its laws, or else endeavor to change those laws. This notion of citizenship, which in Athens was linked to native birth (thus excluding slaves and foreigners) must be injected with new meaning today and be extended to new immigrants who have chosen to stay; this notion of citizenship must offer them membership in a community of knowledge and opinions.

A new citizenship pact is necessary today, not just in Venice but everywhere else too, both for families native to their city

and those who have come from other places. In Venice's case, this new pact will have to begin from a strong sense of commitment to spur politicians and public institutions to adopt a more creative outlook toward the city, to bring the historic city back to life and gear it toward the future, the means to create a new kind of politics to stem the perverse logic causing the exodus of citizens, and to encourage the young to remain via strong incentives such as tax breaks. It would also mean curbing the rampant proliferation of second homes and the transformation of buildings into nothing more than hotels. It would mean encouraging manufacturing and private enterprise as well as generating opportunities for a wider range of creative jobs. It would mean reunifying the historic city, lagoon, and mainland by differentiating their functions, making more agricultural land available and investing in new fisheries, reutilizing old, vacant buildings, incentivizing research, launching new professional training schemes and apprenticeships and investing in universities, chiefly by making it affordable for students to actually live in the city. It would mean developing new models, analyzing situations, evaluating options, and emphasizing initiatives of a higher caliber (like the universities and the Biennale) and not just enslaving the city to "uncontrollable market forces." It would mean enshrining the right to the city and the common good as our first priority.

If we think of Venice as a paradigm of the historic city, its beauty should also be considered a part of this debate. Beauty, after all, isn't a commodity, but is instead part of our spiritual heritage. We cannot acquiesce to a process where:

> subjectivity turns the beautiful into things—the
> grove into timber, the images into things that
> have eyes and do not see, ears and do not hear.

> And if the ideals cannot be reduced to the block
> and stones of a wholly explicable [*verständig*] re-
> ality, they are made into fictions. Any connection
> with the ideals will then appear as a play without
> substance, or as dependence upon objects and as
> superstition (Hegel, *Faith and Knowledge*, 1802).

Thinking about historic cities also means thinking about
human communities, the right to work, and the right to the
city. Administrators, developers, and architects must renounce
any architecture of oppression and show that nonviolent forms
of modernity are attainable.

As for Venetians—as well as anyone else who has a special
place for that city in their heart—they have serious responsi-
bilities and crucial tasks ahead of them: to prove that the city's
beauty and diversity are not just cumbersome legacies of the
past, but an extraordinary gift that allows us to embrace the
present and an extraordinary endowment for building and
securing the future; to prove that Venice doesn't have to trans-
form itself into Chongqing to survive in this century, and that
Venice must in fact be its antithesis. That there is room in this
world for a wide variety of urban models, culture, and life-
styles; and that the model produced by Venice over the course
of centuries entails for itself a right to citizenship, a right to
remain alive in this world both now and for generations to
come. Because if Venice dies, it won't be the only thing that
dies: the very idea of the city—as an open space where diver-
sity and social life can unfold, as the supreme creation of our
civilization, as a commitment to and promise of democracy—
will also die with it.

THE MADONNA OF NOTRE DAME
BY ALEXIS RAGOUGNEAU

FIFTY THOUSAND BELIEVERS AND PHOTO-HUNGRY tourists jam into Notre Dame Cathedral to celebrate the Feast of the Assumption. The next morning, a stunningly beautiful young woman kneels at prayer in a cathedral side chapel. But when an American tourist accidentally bumps against her, her body collapses. This thrilling murder mystery illuminates shadowy corners of the world's most famous cathedral, shedding light on good and evil with suspense, compassion and wry humor.

A VERY RUSSIAN CHRISTMAS

THIS IS RUSSIAN CHRISTMAS CELEBRATED IN supreme pleasure and pain by the greatest of writers, from Dostoevsky and Tolstoy to Chekhov and Teffi. The dozen stories in this collection will satisfy every reader, and with their wit, humor, and tenderness, packed full of sentimental songs, footmen, whirling winds, solitary nights, snow drifts, and hopeful children, the collection proves that Nobody Does Christmas Like the Russians.

YEAR OF THE COMET BY SERGEI LEBEDEV

FROM THE CRITICALLY ACCLAIMED AUTHOR OF *Oblivion* comes *Year of the Comet*, a story of a Russian boyhood and coming of age as the Soviet Union is on the brink of collapse. Sergei Lebedev depicts a vast empire coming apart at the seams, transforming a very public moment into something tender and personal, and writes with shattering beauty and insight about childhood and the growing consciousness of a boy in the world.

Moving the Palace
by Charif Majdalani

A YOUNG LEBANESE ADVENTURER EXPLORES the wilds of Africa, encountering an eccentric English colonel in Sudan and enlisting in his service. In this lush chronicle of far-flung adventure, the military recruit crosses paths with a compatriot who has dismantled a sumptuous palace and is transporting it across the continent on a camel caravan. This is a captivating modern-day Odyssey in the tradition of Bruce Chatwin and Paul Theroux.

Adua by Igiaba Scego

Adua, AN IMMIGRANT FROM SOMALIA TO ITALY, has lived in Rome for nearly forty years. She came seeking freedom from a strict father and an oppressive regime, but her dreams of film stardom ended in shame. Now that the civil war in Somalia is over, her homeland calls her. She must decide whether to return and reclaim her inheritance, but also how to take charge of her own story and build a future.

The 6:41 to Paris
by Jean-Philippe Blondel

CÉCILE, A STYLISH 47-YEAR-OLD, HAS SPENT the weekend visiting her parents outside Paris. By Monday morning, she's exhausted. These trips back home are stressful and she settles into a train compartment with an empty seat beside her. But it's soon occupied by a man she recognizes as Philippe Leduc, with whom she had a passionate affair that ended in her brutal humiliation 30 years ago. In the fraught hour and a half that ensues, Cécile and Philippe hurtle towards the French capital in a psychological thriller about the pain and promise of past romance.

ON THE RUN WITH MARY
BY JONATHAN BARROW

SHINING MOMENTS OF TENDER BEAUTY PUNC-
tuate this story of a youth on the run after es-
caping from an elite English boarding school.
At London's Euston Station, the narrator
meets a talking dachshund named Mary and
together they're off on escapades through posh
Mayfair streets and jaunts in a Rolls-Royce.
But the youth soon realizes that the seemingly
sweet dog is a handful; an alcoholic, nymphomaniac, drug-addicted
mess who can't stay out of pubs or off the dance floor. *On the Run with
Mary* mirrors the horrors and the joys of the terrible 20th century.

OBLIVION BY SERGEI LEBEDEV

IN ONE OF THE FIRST 21ST CENTURY RUSSIAN
novels to probe the legacy of the Soviet prison
camp system, a young man travels to the vast
wastelands of the Far North to uncover the
truth about a shadowy neighbor who saved his
life, and whom he knows only as Grandfather
II. Emerging from today's Russia, where the
ills of the past are being forcefully erased from
public memory, this masterful novel represents
an epic literary attempt to rescue history from the brink of oblivion.

THE LAST WEYNFELDT BY MARTIN SUTER

ADRIAN WEYNFELDT IS AN ART EXPERT IN AN
international auction house, a bachelor in his
mid-fifties living in a grand Zurich apartment
filled with costly paintings and antiques. Always
correct and well-mannered, he's given up on
love until one night—entirely out of character
for him—Weynfeldt decides to take home a
ravishing but unaccountable young woman and
gets embroiled in an art forgery scheme that
threatens his buttoned up existence. This refined page-turner moves be-
hind elegant bourgeois facades into darker recesses of the heart.

THE LAST SUPPER BY KLAUS WIVEL
ALARMED BY THE OPPRESSION OF 7.5 MILLION Christians in the Middle East, journalist Klaus Wivel traveled to Iraq, Lebanon, Egypt, and the Palestinian territories to learn about their fate. He found a minority under threat of death and humiliation, desperate in the face of rising Islamic extremism and without hope their situation will improve. An unsettling account of a severely beleaguered religious group living, so it seems, on borrowed time. Wivel asks, Why have we not done more to protect these people?

GUYS LIKE ME BY DOMINIQUE FABRE
DOMINIQUE FABRE, BORN IN PARIS AND A lifelong resident of the city, exposes the shadowy, anonymous lives of many who inhabit the French capital. In this quiet, subdued tale, a middle-aged office worker, divorced and alienated from his only son, meets up with two childhood friends who are similarly adrift. He's looking for a second act to his mournful life, seeking the harbor of love and a true connection with his son. Set in palpably real Paris streets that feel miles away from the City of Light, a stirring novel of regret and absence, yet not without a glimmer of hope.

ANIMAL INTERNET BY ALEXANDER PSCHERA
SOME 50,000 CREATURES AROUND THE GLOBE— including whales, leopards, flamingoes, bats and snails—are being equipped with digital tracking devices. The data gathered and studied by major scientific institutes about their behavior will warn us about tsunamis, earthquakes and volcanic eruptions, but also radically transform our relationship to the natural world. Contrary to pessimistic fears, author Alexander Pschera sees the Internet as creating a historic opportunity for a new dialogue between man and nature.

KILLING AUNTIE BY ANDRZEJ BURSA

A YOUNG UNIVERSITY STUDENT NAMED JUREK, with no particular ambitions or talents, finds himself with nothing to do. After his doting aunt asks the young man to perform a small chore, he decides to kill her for no good reason other than, perhaps, boredom. This short comedic masterpiece combines elements of Dostoevsky, Sartre, Kafka, and Heller, coming together to produce an unforgettable tale of murder and—just maybe—redemption.

I CALLED HIM NECKTIE
BY MILENA MICHIKO FLAŠAR

TWENTY-YEAR-OLD TAGUCHI HIRO HAS SPENT the last two years of his life living as a hikikomori—a shut-in who never leaves his room and has no human interaction—in his parents' home in Tokyo. As Hiro tentatively decides to reenter the world, he spends his days observing life from a park bench. Gradually he makes friends with Ohara Tetsu, a salaryman who has lost his job. The two discover in their sadness a common bond. This beautiful novel is moving, unforgettable, and full of surprises.

WHO IS MARTHA? BY MARJANA GAPONENKO

IN THIS ROLLICKING NOVEL, 96-YEAR-OLD ornithologist Luka Levadski foregoes treatment for lung cancer and moves from Ukraine to Vienna to make a grand exit in a luxury suite at the Hotel Imperial. He reflects on his past while indulging in Viennese cakes and savoring music in a gilded concert hall. Levadski was born in 1914, the same year that Martha—the last of the now-extinct passenger pigeons—died. Levadski himself has an acute sense of being the last of a species. This gloriously written tale mixes piquant wit with lofty musings about life, friendship, aging and death.

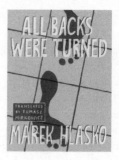

ALL BACKS WERE TURNED BY MAREK HLASKO
TWO DESPERATE FRIENDS—ON THE EDGE OF
the law—travel to the southern Israeli city of
Eilat to find work. There, Dov Ben Dov, the
handsome native Israeli with a reputation for
causing trouble, and Israel, his sidekick, stay
with Ben Dov's younger brother, Little Dov,
who has enough trouble of his own. Local
toughs are encroaching on Little Dov's busi-
ness, and he enlists his older brother to drive
them away. It doesn't help that a beautiful German widow is rooming
next door. A story of passion, deception, violence, and betrayal, con-
veyed in hard-boiled prose reminiscent of Hammett and Chandler.

ALEXANDRIAN SUMMER
BY YITZHAK GORMEZANO GOREN
THIS IS THE STORY OF TWO JEWISH FAMILIES
living their frenzied last days in the doomed
cosmopolitan social whirl of Alexandria just
before fleeing Egypt for Israel in 1951. The
conventions of the Egyptian upper-middle
class are laid bare in this dazzling novel, which
exposes sexual hypocrisies and portrays a van-
ished polyglot world of horse racing, seaside
promenades and nightclubs.

COCAINE BY PITIGRILLI
PARIS IN THE 1920S—DIZZY AND DECADENT.
Where a young man can make a fortune with
his wits … unless he is led into temptation.
Cocaine's dandified hero Tito Arnaudi invents
lurid scandals and gruesome deaths, and sells
these stories to the newspapers. But his own
life becomes even more outrageous when he
acquires three demanding mistresses. Elegant,
witty and wicked, Pitigrilli's classic novel was
first published in Italian in 1921 and retains its venom even today.

KILLING THE SECOND DOG
BY MAREK HLASKO

TWO DOWN-AND-OUT POLISH CON MEN LIVING in Israel in the 1950s scam an American widow visiting the country. Robert, who masterminds the scheme, and Jacob, who acts it out, are tough, desperate men, exiled from their native land and adrift in the hot, nasty underworld of Tel Aviv. Robert arranges for Jacob to run into the widow who has enough trouble with her young son to keep her occupied all day. What follows is a story of romance, deception, cruelty and shame. Hlasko's writing combines brutal realism with smoky, hard-boiled dialogue, in a bleak world where violence is the norm and love is often only an act.

FANNY VON ARNSTEIN: DAUGHTER OF THE
ENLIGHTENMENT BY HILDE SPIEL

IN 1776 FANNY VON ARNSTEIN, THE DAUGHTER of the Jewish master of the royal mint in Berlin, came to Vienna as an 18-year-old bride. She married a financier to the Austro-Hungarian imperial court, and hosted an ever more splendid salon which attracted luminaries of the day. Spiel's elegantly written and carefully researched biography provides a vivid portrait of a passionate woman who advocated for the rights of Jews, and illuminates a central era in European cultural and social history.

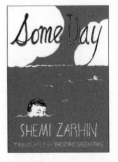

SOME DAY BY SHEMI ZARHIN

ON THE SHORES OF ISRAEL'S SEA OF GALILEE lies the city of Tiberias, a place bursting with sexuality and longing for love. The air is saturated with smells of cooking and passion. *Some Day* is a gripping family saga, a sensual and emotional feast that plays out over decades. This is an enchanting tale about tragic fates that disrupt families and break our hearts. Zarhin's hypnotic writing renders a painfully delicious vision of individual lives behind Israel's larger national story.

THE MISSING YEAR OF JUAN SALVATIERRA
BY PEDRO MAIRAL

AT THE AGE OF NINE, JUAN SALVATIERRA became mute following a horse riding accident. At twenty, he began secretly painting a series of canvases on which he detailed six decades of life in his village on Argentina's frontier with Uruguay. After his death, his sons return to deal with their inheritance: a shed packed with rolls over two miles long. But an essential roll is missing. A search ensues that illuminates links between art and life, with past family secrets casting their shadows on the present.

THE GOOD LIFE ELSEWHERE
BY VLADIMIR LORCHENKOV

THE VERY FUNNY—AND VERY SAD—STORY OF A group of villagers and their tragicomic efforts to emigrate from Europe's most impoverished nation to Italy for work. An Orthodox priest is deserted by his wife for an art-dealing atheist; a mechanic redesigns his tractor for travel by air and sea; and thousands of villagers take to the road on a modern-day religious crusade to make it to the Italian Promised Land. A country where 25 percent of its population works abroad, remittances make up nearly 40 percent of GDP, and alcohol consumption per capita is the world's highest – Moldova surely has its problems. But, as Lorchenkov vividly shows, it's also a country whose residents don't give up easily.

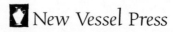 New Vessel Press

To purchase these titles and for more information please visit newvesselpress.com.